CHICAGO'S
SOLDIER FIELD

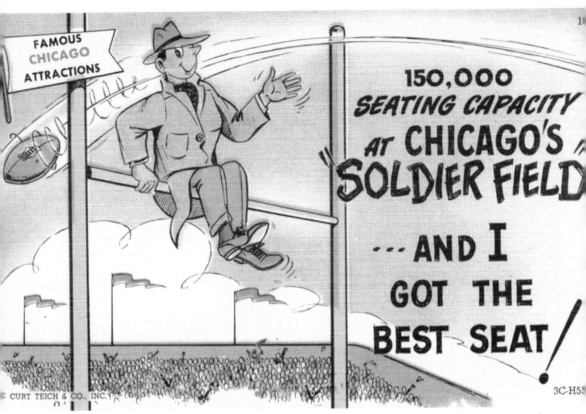

The Curt Teich Company of Chicago operated from 1898 to 1978, producing landscape views and advertisement postcards. This novelty cartoon postcard from the 1950s advertises Soldier Field's 150,000 seating capacity. In September 1971, when the Chicago Bears first made the stadium their permanent home, seating capacity had been reduced to 57,000 to allow spectators a relatively clear view of the field. In 1978, the plank seating was replaced by individual seats with backs and armrests. Despite continued remodeling, the sight lines for football were far from ideal.

On the front cover: Crowds wait eagerly behind Chicago Police Department barricades outside of Soldier Field's Gate 0 during the January 21, 2007, NFC championship game. (Author's collection.)

On the back cover: Soldier Field is seen as it appeared before the stadium underwent its $365 million reconstruction. (Author's collection.)

Cover background: A 1930s image reflects the Chicago Bears playing at Soldier Field decades before the team made the stadium their permanent home. (Author's collection.)

CHICAGO'S
SOLDIER FIELD

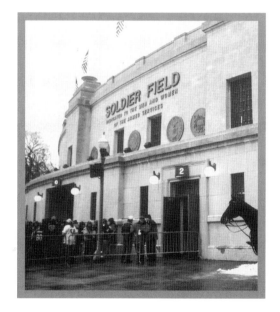

Paul Michael Peterson

ARCADIA
PUBLISHING

Published by Arcadia Publishing
Charleston SC, Chicago IL, Portsmouth NH, San Francisco CA

Printed in the United States of America

Library of Congress Catalog Card Number: 2007929687

For all general information contact Arcadia Publishing at:
Telephone 843-853-2070
Fax 843-853-0044
E-mail sales@arcadiapublishing.com
For customer service and orders:
Toll-Free 1-888-313-2665

Visit us on the Internet at www.arcadiapublishing.com

This book is dedicated to the memory of Darryl Stingley

CONTENTS

ACKNOWLEDGMENTS

For their time and encouragement, the author wishes to thank the following individuals whose assistance with this project is, and always will be, greatly appreciated: Jaime Danehey, marketing coordinator for Holabird and Root LLC; Tony Cerialej; Sheila Davis, reference librarian for the Skokie Public Library; Barbara Diguido, director of communication and media relations for Special Olympics Illinois; Jane Hagedorn, reference librarian for the Skokie Public Library; Roy Kaltschmidt; Kathy McLaughlin, manager of development for the Chicago/Area 3 office of Special Olympics Illinois; John Pearson of Arcadia Publishing; Sharon and Bruce Peterson; Tiger Tom Pistone; the Franklin D. Roosevelt Library in Hyde Park, New York; Jeff Ruetsche of Arcadia Publishing; special thanks to Butchie, for keeping my books on his coffee table; and finally, Joan Peterson and Michael Peterson, whose unwavering love and support continue to inspire me each day.

Any sins of omission regarding photographs, credits, and/or facts and dates rest entirely with the responsibility of the author and were unintentional.

INTRODUCTION

Landfill use can be credited as the genesis for what we refer to today as Soldier Field.

Daniel Hudson Burnham, through his 1909 *Plan of Chicago*, had outlined a system with parks and wide avenues, transportation, and recreation as the organizing principle for the surrounding buildings, streets, and parks. In the years following Burnham's death in 1912, the development of the lakefront parks with architectural and cultural enrichments metamorphosed into reality.

Soldier Field was designed in 1919 and opened on October 9, 1924 (the 53rd anniversary of the Chicago Fire), as Municipal Grant Park Stadium. The stadium was modeled in the Greco-Roman architectural tradition with classic Doric colonnades rising 100 feet above the playing field. Designed by the Chicago architecture firm Holabird and Root (later changed to Holabird and Roche), the civic structure was intended to serve as a memorial to American soldiers who died in World War I. Original construction costs when the project broke ground in 1922 were estimated at $10 million. The structure that later became known as Soldier Field in 1926 stood on 10,000 pile foundations, driving an average depth of 62.5 feet through landfill that replaced Lake Michigan's waters.

Eight decades later with the advent of the 21st century, a dramatic reconstruction plan for Soldier Field and the surrounding area approached a cost of $365 million as the majority of the stadium was demolished, save for the exterior. The "new" Soldier Field drew mixed reviews when it reopened in 2003. After being rebuilt, the modern stands dwarfed the historic Doric columns and seating was reduced by approximately 5,000 to 61,500. Although Soldier Field lost its historic landmark designation in 2006 due to the extent of the renovations, it continues to inspire people as a long-standing civic structure illustrative of Chicago's "I Will" spirit.

Just prior to this book's printing and by my last count on Amazon.com, more than two dozen books about the Chicago Bears existed in the World Wide Web marketplace. By comparison, there is only one book that I was able to locate dedicated entirely to the subject of Soldier Field: a 2005 box set hardcover titled *Soldier Field* by Jay Pridmore and Douglas Reid Fogelson. Thus, an apology to the reader: this book's central focus attempts a historical photographic journey around the creation and evolution of the stadium located at 1410 South Museum Campus Drive. Football fans will find fewer images of the Chicago Bears contained in these pages than can be found in the two dozen books mentioned above. The story of Soldier Field and its surrounding environs, however, is just as exciting as an afternoon spent enjoying the action of the gridiron; the pages of Chicago's past promise a storied history for those willing to mine its chapters.

This is the pictorial story of architecture, urban history, religion, boxing matches, automobile racing, famous people who have influenced world and cultural affairs, and yes, even football, both at the collegiate and professional levels. It is my ardent hope that this book serves as one small piece in the extensive jigsaw puzzle that is Chicago, and more importantly, that you, the reader, enjoy it.

—Paul Michael Peterson
Chicago, June 2007

ORIGINS AND

EARLY YEARS

Make no small plans; for they lack the magic to stir men's blood and probably themselves will not be realized. Make big plans; aim high in hope and work, remembering that a noble and logical diagram once recorded will never die, but long after we are gone will be a living thing.

—Daniel Hudson Burnham (1846–1912), American architect and urban planner

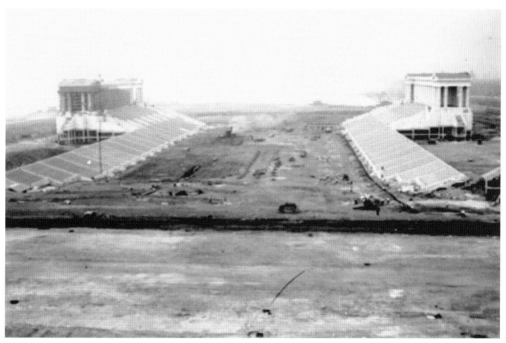

The land now known as Soldier Field was once barren and desolate, sitting just a few steps south of the Field Museum (which moved in 1921 from its original location in Jackson Park). The stadium, seen here in the infancy of construction, was originally known as Municipal Grant Park Stadium.

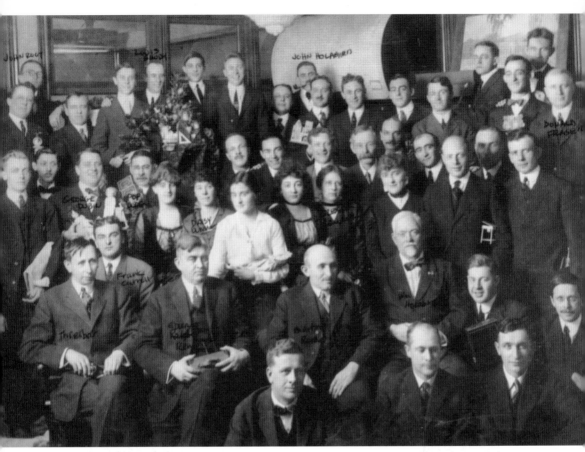

The firm of Holabird and Roche was part of the "Chicago School," an architectural style launched with the advent of the Chicago skyscraper. Holabird and Roche designed rational and utilitarian skyscrapers. Notable Holabird and Roche commissions include the Tacoma Building of 1888, the Marquette Building of 1894, and Soldier Field (Chicago) of 1920. Plans for the stadium began in 1919, when Holabird and Roche won an architectural competition to build the stadium as a memorial to American soldiers who died in wars (most notably, World War I, which ended in 1918). The successor firm of Holabird and Roche was formed in 1929 after the deaths of William Holabird and Martin Roche. John Holabird (William Holabird's son) along with John Root Jr. (the son of John Wellborn Root, who had worked with and befriended Daniel Hudson Burnham, pictured opposite), later renamed the firm Holabird and Root. In the group photograph above from around 1915, both Root and Holabird are pictured in the back row. (Courtesy of Holabird and Root.)

ORIGINS AND EARLY YEARS

Daniel Hudson Burnham (1846–1912) was an American architect and one of the first urban planners who prepared *The Plan of Chicago*, which was published in 1909. This ambitious proposal included a comprehensive plan for the future growth of the city and set the standard for modern urban planning. Burnham's career work was heavily influenced by the classical style of Greece and Rome, and he believed that every citizen should be within walking distance of a park. One quote from his 1909 work might be applied to the construction of Soldier Field: "First in importance is the shore of Lake Michigan. It should be treated as park space to the greatest possible extent. The lakefront by right belongs to the people . . . not a foot of its shores should be appropriated to the exclusion of the people."

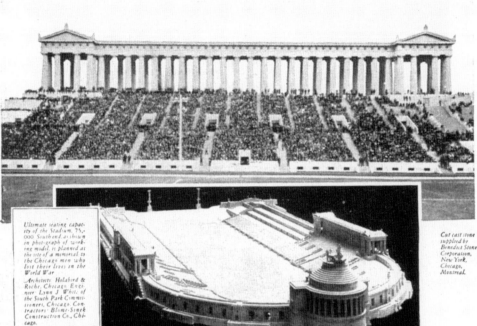

Ancient Greece in Modern Concrete

Displayed above is a 1925 advertisement highlighting Grant Park Stadium's/Soldier Field's construction from the Portland Cement Association, which boasts that with concrete "beauty, as well as construction, is made permanent." Concrete was an inexpensive alternative to carved stone.

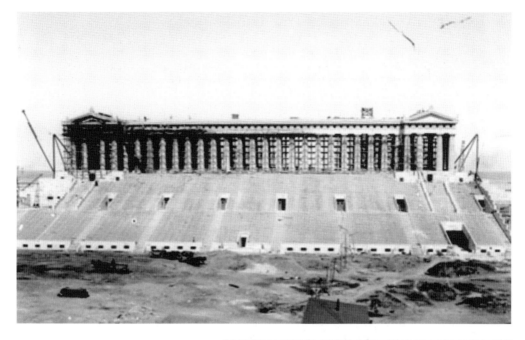

Pictured here are two "then and now" photographs: the first is an early 1920s photograph of the construction work to which the Portland Cement Company contributed. The second image is a modern view of the neoclassical Doric colonnades that now frame the margins of Soldier Field's 2003 reconstruction. The colonnades rise 100 feet in the monument to the men and women who gave their service and lives in World War I and all wars before and since.

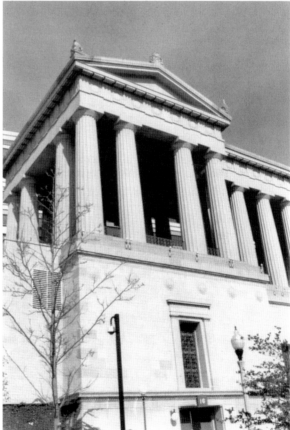

Frank Orren Lowden (1861–1943) was a Congressional representative from Illinois from 1906 to 1911. He served as governor of Illinois from 1917 to 1921, declining the Republican nomination for vice president in 1924. In 1925, Lowden was instrumental in renaming Municipal Grant Park Stadium to Soldier Field in memory of Americans killed in World War I and "to all the fallen heroes of all the wars ever fought."

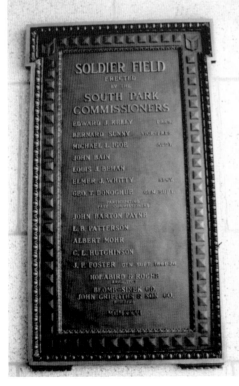

A bronze plaque adorns the south entrance of Soldier Field today and names all of the principal Chicago players responsible for its creation. The South Park Commissioners was early nomenclature for the Chicago Park District of today.

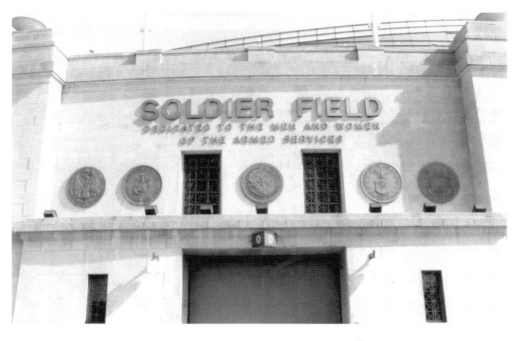

Pictured above is a view of the main entrance to Soldier Field with the dedication listed beneath. The circular plaques above the entranceway serve to highlight each branch of the American military. Pictured at right is a copy of a program cover to the Army-Navy football game at Soldier Field for Saturday, November 27, 1926, when the formal dedication of the stadium's new name took place.

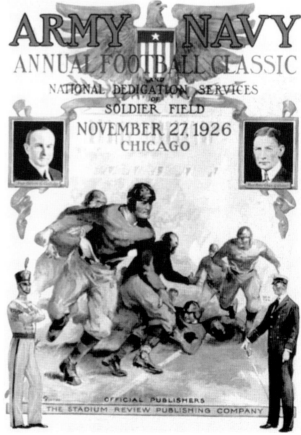

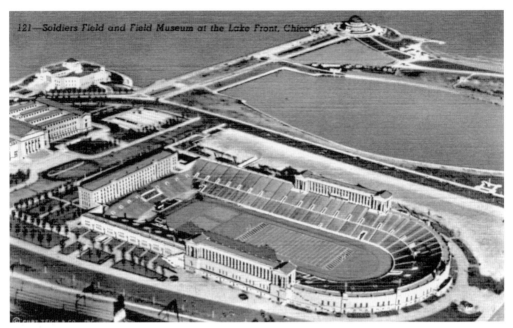

These postcards from the mid-1920s portray differing views of what was erroneously referred to as "Soldiers' Field". Many native Chicagoans today continue to mistakenly employ the plural form.

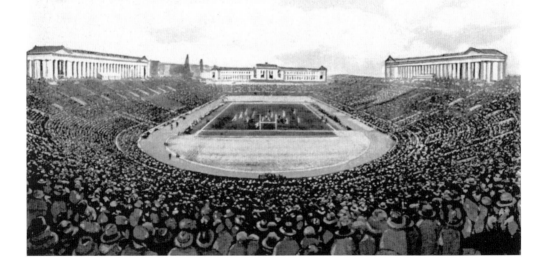

ORIGINS AND EARLY YEARS

THE LONG COUNT

When a knockdown occurs, the timekeeper shall immediately arise and announce the seconds audibly as they elapse. The referee shall see first that the opponent retires to the farthest neutral corner and then, turning to the timekeeper, shall pick up the count in unison with him, announcing the seconds to the boxer on the floor. Should the boxer on his feet fail to go, or stay, in the corner, the referee and timekeeper shall cease counting until he has so retired.

—The Neutral Corner Rule in boxing

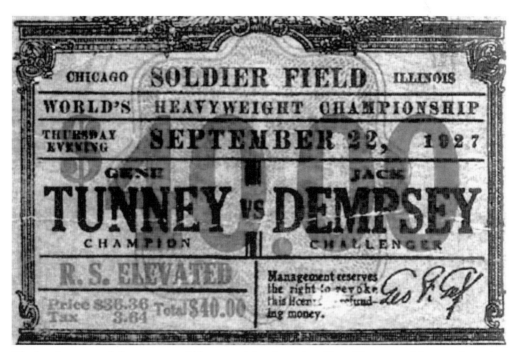

The boxing rematch between world heavyweight champion Gene Tunney and former champion Jack Dempsey occurred on September 22, 1927, at Soldier Field before 104,000 boxing fans following Dempsey's defeat by Tunney in Philadelphia the year before. Soldier Field's construction in the early 1920s and the famous rematch between Tunney and Dempsey were perfectly timed, as this decade was known as the "Golden Age of Sports." The end of World War I brought Americans a renewed sense of optimism, greater economic prosperity, and more leisure time with the advent of the automobile. Pictured above is a ticket to the much-heralded event. The $40 price tag was a high price for the average wage earner in 1927, but well worth the cost of seeing two gladiators do battle in a modern athletic coliseum.

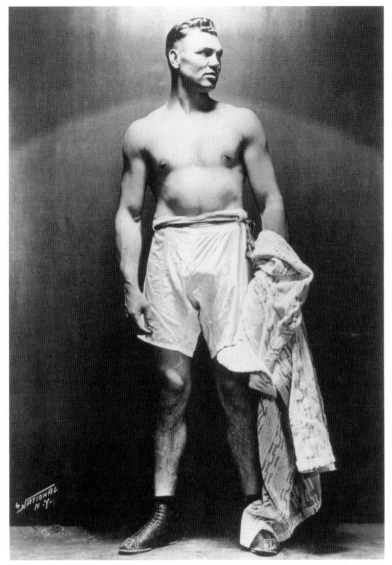

William Harrison Dempsey (1895–1983) was born in Manassa, Colorado, as one of 11 children in a poor family. Dempsey left home during his teenage years, traveling west on freight trains with hobos and settling occasionally in mining towns. It was during this period of his life that Dempsey learned how to fight as a means of survival. In an effort to earn money, Dempsey would occasionally frequent saloons and challenge others to fights saying, "I can't sing and I can't dance, but I can lick any S.O.B. in the house." Dempsey rarely lost the wagers as a result of his fighting skill. He later became known as "the Manassa Mauler," holding the world heavyweight title between 1919 and 1926. The late Jim Murray, former *Los Angeles Times* sports columnist, captured Dempsey's larger-than-life character: "Whenever I hear the name, Jack Dempsey, I think of an America that was one big roaring camp of miners, drifters, bunkhouse hands, con men, hard cases, men who lived by their fists and their shooting irons and by the cards they drew. America at High Noon."

THE LONG COUNT

James Joseph "Gene" Tunney (1897–1978) was born in New York and began boxing while working in his late teenage years as a clerk for the Ocean Steamship Company in New York. He joined the United States Marine Corps during World War I. While in Paris in 1919, Tunney won the light heavyweight championship of the American Expeditionary Forces. Tunney was both articulate and literate, having maintained friendships with notable writers Ernest Hemingway and W. Somerset Maugham. While he abstained from alcohol and kept a strict physical fitness routine, Tunney was not gifted with great speed or strength in the ring. Instead Tunney preferred to outbox his opponents rather than knock them out. He was the heavyweight boxing champion from 1926 to 1928.

Tunney-Dempsey Boxing Contest

Soldier Field, Grant Park, Chicago, September 22nd, 1927

Ticket Holders are requested to study the following carefully. Map of the Stadium is on the back of this sheet of instructions.

THE GATES OPEN AT 5:00 P. M. TO AVOID CONGESTION AND DELAY, COME EARLY

TICKETS:
Without a Ticket, no one will be admitted to Grant Park after 4 p. m.
Ticket admits only at Stadium Gate, and to Seat Section designated; locate your Gate on Map.
Entering Stadium, Ticket holders must go direct and at once, to their seats.
No one will be allowed to roam about, or stand or sit in the aisles.
Ticket holders must show Ticket to enter (a) the Park; (b) their Gate; (c) and Section.

HAVE IT READY:
Each individual Ticket holder must hold his own ticket, as everyone must have a ticket.
Inside the Stadium, Tickets must be shown when called for by Police or Attendants.
Tickets are not good for re-admission, nor after stub is detached, at the Gate.
No return checks or "pass out" tickets will be issued.

SEATING:
Permanent Stand Seats are numbered from South to North; Field Seats from service aisle inward.
Rows in each Section are numbered from front to back, facing the Ring.
Gates with even numbers are on East side of Stadium; odd numbered Gates on West Side.
Gate O is at South Center of the Stadium; Gate 50 at the North Center, on axis line.

TRAFFIC:
Traffic from South and West Sides of the city is advised to enter Park by 23rd St. Viaduct.
Traffic from North Side and Loop will enter Park by Monroe, Jackson, 7th and 8th Sts. Bridges.
Pedestrians will have exclusive use of 11th St. Bridge.
Tickets must be shown to permit bearer to cross Bridges entering the Park.
No parking of cars permitted, outside of Monroe St. paid parking space, before 4 p. m.
Parking of cars entering from the North will be north of Field Museum.
Parking of cars entering from South permitted only south of 16th Street, south of Stadium.
Busses and Taxis will operate a shuttle service from all bridges to the Stadium approaches.
After program, patrons must go to cars; cars not permitted to pick them up at Stadium doors.
Before or after program, no private cars permitted between Roosevelt Road and 16th Street.
Cars parked south of Stadium leave by South bridge; those north by North bridge, after the program.
Leaving parking space, all cars must turn East to East Drive, after program ends.
Pedestrians will have exclusive use of West Drive after program, and of 11th Street Bridge, leaving the Stadium.
Patrons arriving by Illinois Central may use either 18th Street or 12th Street Stations.

CONVENIENCES AND SAFETY:
A Lost and Found Service will patrol under all temporary seats; inquiries should be made at the headquarters office under the structure at the South End, Gate O.
Toilet accommodations under seats and in main structure; inquire of ushers.
Hospital and First Aid organization under main stand, on either side; service free.
If any accident occurs it should be reported to head usher before leaving grounds.
Fire Patrols will operate under all structures throughout the program.
Telegraph and telephone wires, under main stand on either side of the field.
An Outside Field Office, south of the Stadium, will be open to furnish information and decide all disputed questions before patrons enter the structure; consult them in difficulties.
Inside the structure an inner Field Office at the South End, Gate O, will render all possible assistance to patrons applying there.
A flashlight picture is planned during the evening; public address system will announce it.

COOPERATION:
The management has planned all of the arrangements solely for the comfort, safety and convenience of patrons. Your cooperation is earnestly solicited in helping to carry out the plans. Attendants are under strict discipline; they cannot exceed their orders. If they cannot meet your needs, consult the Field Office staff; it is available either outside or inside the Stadium and will do everything which can be done for patrons.

Instructions detailing ticket rules, seating, traffic, and safety, and a stadium map were distributed to spectators of the "Tunney-Dempsey Boxing Contest."

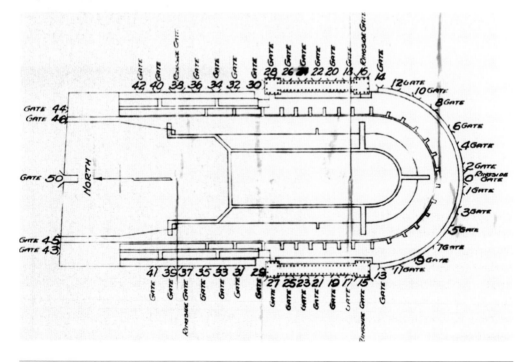

THE LONG COUNT

A varied mix of spectators, from the suited businessman to the United States Navy sailor, lined the far outside perimeters of the stadium, seated on wooden planks. The poor sight lines required the use of binoculars for detailed views in the crowd of over 100,000.

Jack Dempsey stood six feet tall and weighed between 187 and 192 pounds (his highest weight for the fight with Argentinean giant Luis "the Wild Bull of the Pampas" Firpo). Here Dempsey weighs in before the match with Gene Tunney.

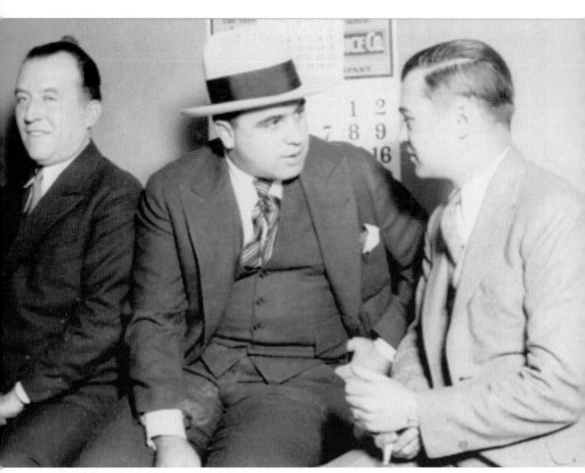

Al Capone (born Alphonse Gabriel Capone in New York on January 17, 1899) was a notorious gangster who christened Prohibition-era Chicago with its reputation for lawlessness. Capone was also Jack Dempsey's most ardent underworld fan, much to Dempsey's embarrassment. Capone reportedly told some reporters of the day that he was betting $50,000 on Dempsey, and that he would ensure that Dempsey got a fair shake. Upon hearing of Capone's comments during his pre-bout training, Dempsey wrote a letter to Capone that read, "Please lay off, Al. Let the fight go on fair, in true sportsmanship. If I beat Tunney, or Tunney beats me in true sportsmanship, it will prove who really deserves to be champion . . . Your friend, Jack Dempsey." Capone responded by having 300 pink roses sent to Dempsey's training camp with a note that read, "To the Dempsey's, in the name of sportsmanship." Thus, with strength of character, Dempsey had successfully stymied Capone's efforts for an unfair victory.

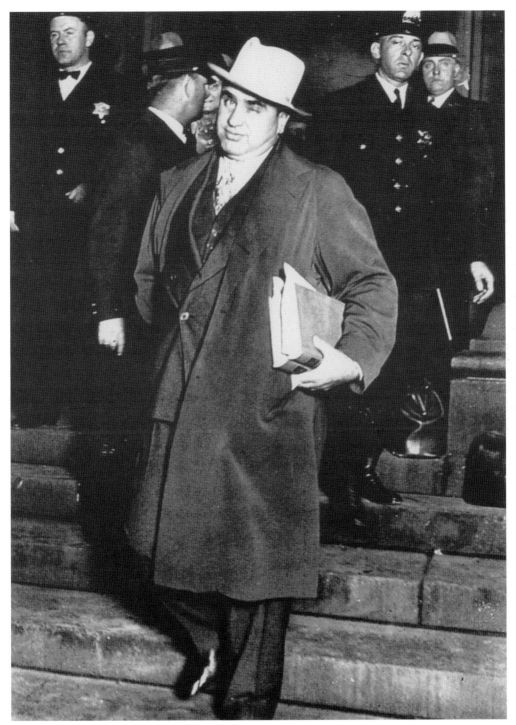

Al Capone leaves court just prior to his 1931 conviction for income tax evasion.

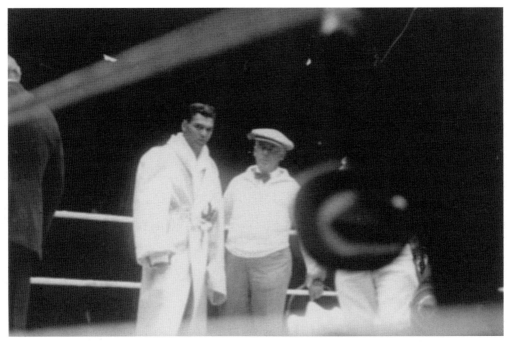

Jack Dempsey stands with manager Leo Flynn in the ring prior to the bout with Gene Tunney. Boxing regulations in Illinois stated that the ring could measure anywhere from 16 to 20 feet along the ropes from corner to corner. The Illinois Boxing Commission decreed that the ring at Soldier Field would be 20 feet. Because Dempsey fought more effectively in a smaller ring where his opponent could not evade him, Flynn had argued—unsuccessfully—for a smaller ring, as seen in the action shot below.

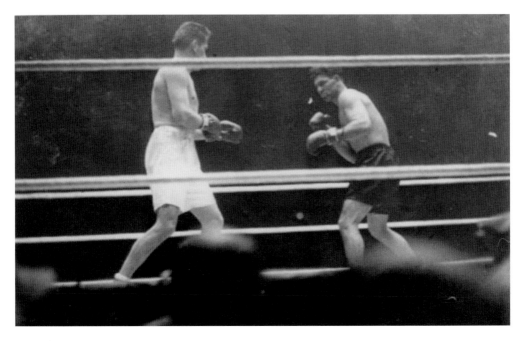

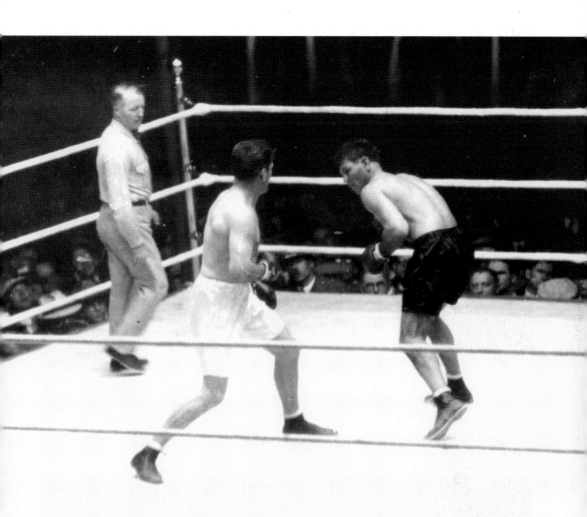

Tunney and Dempsey square off in what would live on in history as the most controversial boxing match of the 20th century.

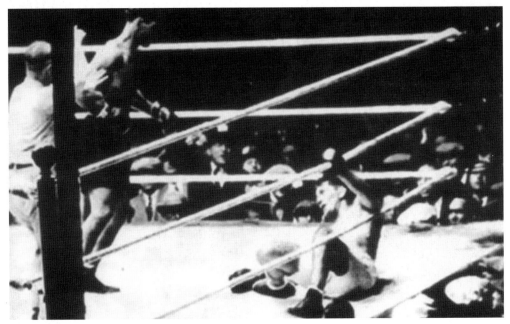

In Round 7, Jack Dempsey unleashed a combination of punches that floored Gene Tunney. For 13 seconds, Dempsey, who ignored the referee's orders to return to a neutral corner, stood over Tunney, observing him. This afforded Tunney precious seconds in which to recuperate. By the eighth round, Tunney dropped Dempsey for a brief moment and went on to retain the world title by a unanimous decision. Some believe that if Dempsey had responded to the referee's orders in time, he would have likely regained the world heavyweight crown with the seventh round knockout of Tunney. Because of this, the championship became known as the "Long Count" fight.

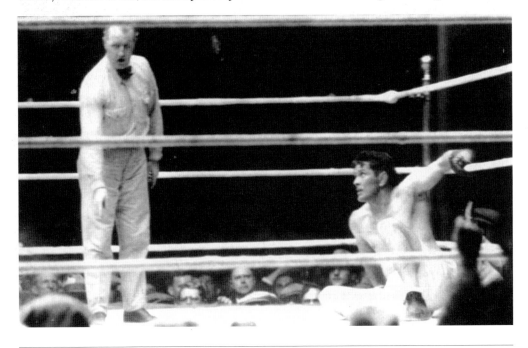

THE LONG COUNT

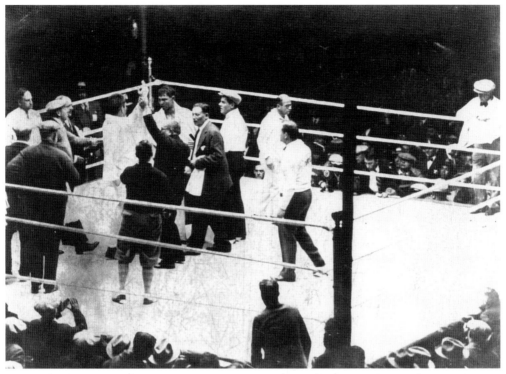

Tunney is declared the heavyweight champion at the end of the 10th round. Gross receipts totaled more than $2.6 million. Tunney earned $990, 445. Dempsey's share was $450,000.

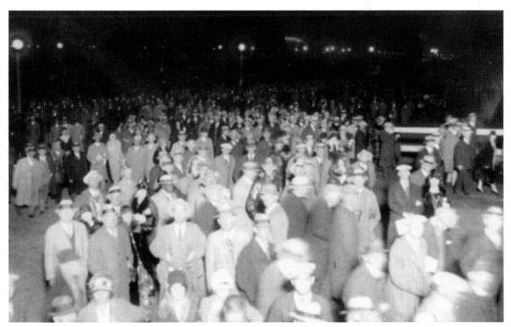

Crowds exit Soldier Field after the famed September 22, 1927, match. Attendance for the evening was 104,943.

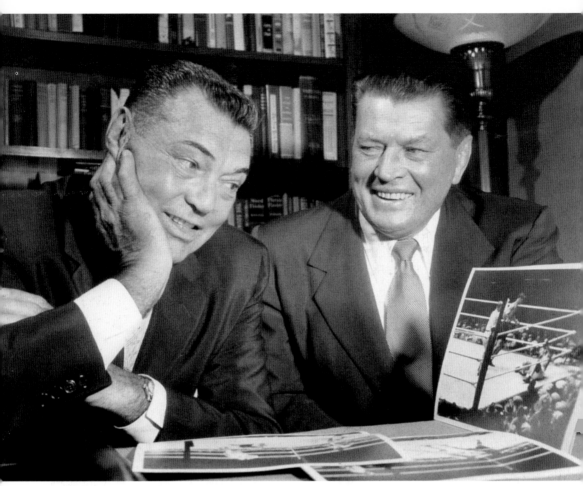

Jack Dempsey and Gene Tunney reminisce in Tunney's New York office in 1957, 30 years after the "Long Count" fight at Chicago's Soldier Field. Dempsey and Tunney became good friends, visiting each other frequently. Tunney died in 1978, and Dempsey followed him in death in 1983. They are both members of the International Boxing Hall of Fame.

ACTION, ATHLETICS,

AND ENTERTAINMENT

To us in America, the reflections of Armistice Day will be filled with solemn pride in the heroism of those who died in the country's service and with gratitude for the victory, both because of the thing from which it has freed us and because of the opportunity it has given America to show her sympathy with peace and justice in the councils of the nation.

—Pres. Woodrow Wilson issuing the Armistice Day proclamation, November 1919

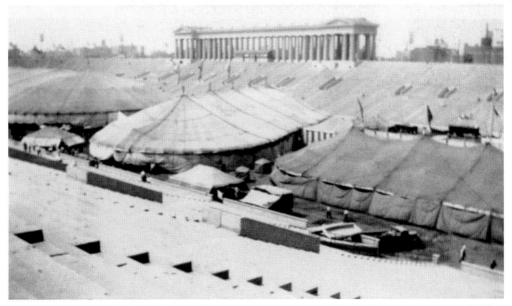

This 1936 photograph shows the Ringling Brothers Barnum and Bailey Circus setting up at Soldier Field in Chicago. Like dozens of small circuses that toured the Midwest and the Northeast at the time, the Ringlings moved their circus from town to town in small animal-drawn caravans. Their circus rapidly grew into one of the largest at the time, and they were soon able to move their circus by train, which enabled them to create the largest traveling show of their time.

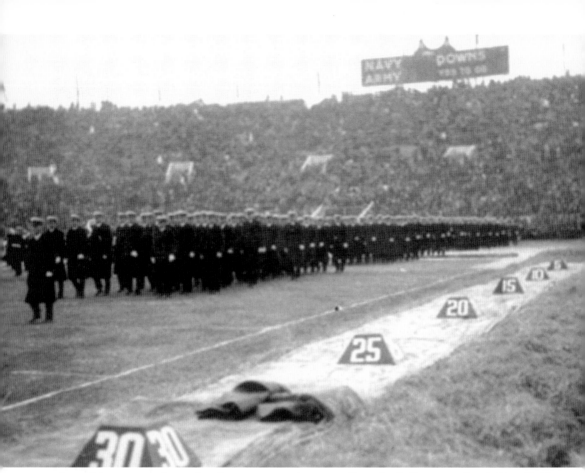

One of the most traditional and intensive rivalries in college football occurred at Soldier Field as more than 100,000 spectators attended the 1926 Army-Navy Game. This game was to decide the championship as Navy entered the event undefeated and Army had only lost to Notre Dame. Although the game ended in a 21-21 score, Navy was awarded the national championship. As a traditional demonstration of respect and solidarity at the end of the game, the alma maters of the losing team and then the winning team are played and sung. The winning team stands alongside the losing team and faces the losing academy students; then the losing team accompanies the winning team, facing their students. Today the championship plaque remains on display at the naval academy. Pictured above are cadets marching on the field prior to the game.

ACTION, ATHLETICS, AND ENTERTAINMENT

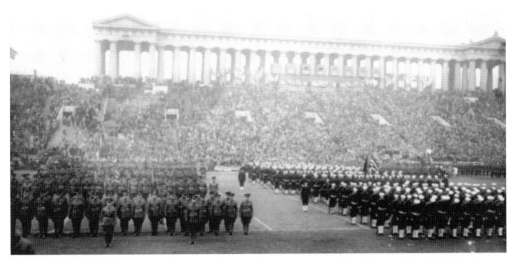

November 11 is the anniversary of the World War I armistice, which was signed in the Forest of Compiegne by the Allies and the Germans in 1918. The treaty for the cessation of hostilities on the "Western Front," which ended World War I after four years of conflict, took effect at 11:00 a.m.—the "eleventh hour of the eleventh day of the eleventh month." Veterans Day, an American holiday honoring military veterans, is celebrated on the same day as Armistice Day (or Remembrance Day in other parts of the world). Pictured above is the November 11, 1929, Armistice Day peace celebration at Soldier Field with United States soldiers and sailors standing in formation on the field. Pictured below are soldiers carrying drums and flags before a sea of spectators.

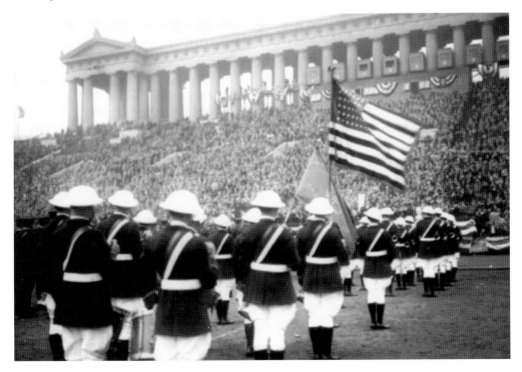

Official Program 15c

—Second Annual—
"WILD WEST" **RODEO** AND **THRILL CIRCUS**
CONCEIVED—PRODUCED—DIRECTED AND PRESENTED BY LARRY SUNBROCK

SUNDAY AUG. 31 AND MONDAY SEPT. 1

2:30 AND 8:00 P.M.

SOLDIER FIELD CHICAGO

Pictured here is a program cover advertising the rodeo at Soldier Field.

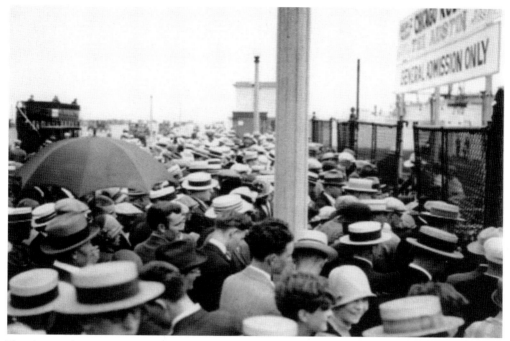

Tex Austin, known as the "King of the Rodeo," was a famous rodeo promoter from 1925 to 1929. Austin considered himself just another cowhand and is said to have punched cattle all over the Southwest. A *Time* magazine article of the day referred to the rodeo as, "the greatest primitive spectacle of the struggle of man against beast that the laws of our land permit." Pictured above, crowds throng Soldier Field's gates for entry. Pictured below, Austin demonstrates his athletic talents on the bronco.

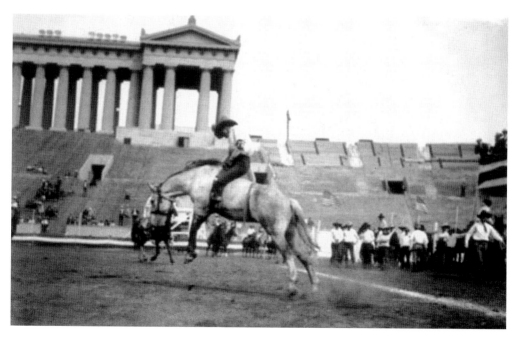

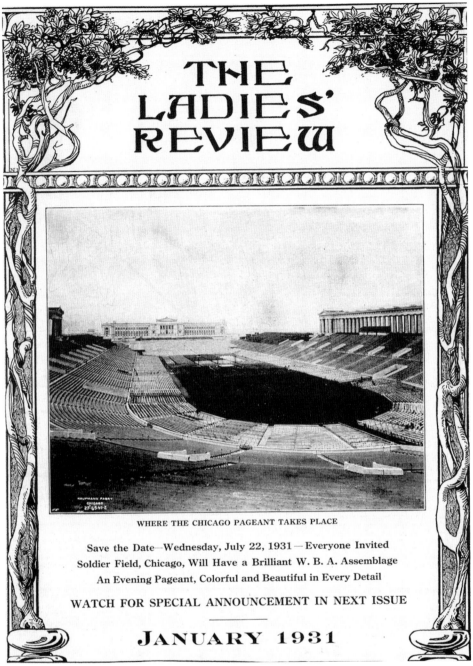

THE LADIES' REVIEW

WHERE THE CHICAGO PAGEANT TAKES PLACE

Save the Date—Wednesday, July 22, 1931—Everyone Invited
Soldier Field, Chicago, Will Have a Brilliant W. B. A. Assemblage
An Evening Pageant, Colorful and Beautiful in Every Detail

WATCH FOR SPECIAL ANNOUNCEMENT IN NEXT ISSUE

JANUARY 1931

The Ladies of the Maccabees was a society of women that offered social and self-improvement activities, as well as life and disability insurance for women and children at a time when neither was common. Founded by Bina West Miller, the organization was later renamed the Woman's Benefit Association. Its membership rose from just over 300 in 1892 to 150,000 by 1904. In 1931, the Woman's Benefit Association hosted its pageant at Chicago's Soldier Field. Pictured above is a sample cover from the monthly newsletter.

THE LADIES' REVIEW

OFFICIAL ORGAN OF THE WOMAN'S BENEFIT ASSOCIATION

ACCEPTANCE FOR MAILING AT SPECIAL RATE OF POSTAGE PROVIDED FOR IN SECTION 1103, ACT OF OCTOBER 3, 1917, AUTHORIZED ON JULY 8, 1918. PUBLISHED MONTHLY AT THE W. B. A. PRINT SHOP, PORT HURON, MICH.

Thirty-seventh Year

Port Huron, Mich.,

Vol. XXXVII. No. 1

January, 1931

ENTERED AT THE POSTOFFICE AT PORT HURON, MICH., AS SECOND CLASS MATTER UNDER ACT OF CONGRESS OF MARCH 3, 1879. ALL RIGHTS RESERVED.

FROM THE EDITOR'S DESK

ARE you ready, member, to make this a Friendly year for the Association?

What old grudges have you got inside of you that are going to spoil some of the lovely days of 1931?

What mouldy, miserable hates rankle your soul when you would be at peace with the world?

Let's have it out with ourselves and get rid of them.

A friend who died last year, when it came to the last, said: "If I could only have the hours back that I wasted in getting even with everyone, how dearly I would live them all over." This might as easily be ourselves saying this.

1931 is here. Henry Van Dyke says of it: "Are you willing to stoop down and consider the needs and the desires of little children; to remember the weakness and loneliness of people who are growing old; to stop asking how much your friends love you, and ask yourself whether you love them enough; to bear in mind the things that other people have to bear on their hearts; to try to understand what those who live in the same house with you really want, without waiting for them to tell you; to trim your lamp so that it will give more light and less smoke, and to carry it in front so that your shadow will fall behind you; to make a grave for your ugly thoughts, and a garden for your kindly feelings, with the gate open—are you willing to do these things even for a day?

And if you do them for a day, why not always?"

✿ ✿ ✿

WHEN a member becomes suspended, the Association has no other choice but to let the member drop her insurance. It has no power to compel her to remain. Its only method of inducing members to make their monthly payments is the provision for suspension for non-payment.

The law providing suspension for non-payment of rates is self-executing. A member suspends herself by failure to pay within the required time.

The Association does not willingly lose any member. It gives every opportunity to her to reinstate within the bounds of safety and reason.

When a member dies while under suspension and her beneficiaries talk loudly against our methods, it is plain that they have not read THE LADIES' REVIEW which has something in every issue regarding suspension and its loss.

Benefits have to be paid with attention to the laws and in accordance with fair business methods.

The safe way to be sure of death benefit payment is for the member to show her interest by not allowing herself to become suspended.

Our Association *is* fraternal—it does its level best to have members see why suspension is dangerous. It sends every member two letters promptly—one from the supreme president and one from the supreme secretary. When no attention is paid to them and the solicitations of financial secretary and reinstatement committee are disregarded, what more can the Association do? Answer this, member, and advise what the next step should be.

✿ ✿ ✿

WHAT are you going to do this year in your review, president, to have the W. B. A. better known in your community? Do your mayor and all the public spirited citizens of your city know about your review and the Association? Your review will follow its leader.

✿ ✿ ✿

THE death from diphtheria of a lapsed junior in an eastern state brings this letter from the press correspondent. This message should urge every parent and guardian to keep her juniors in good standing.

"Enclosed is a clipping about the death of a former junior. It is just another sad case of lapsed insurance. When the family moved here they neglected their payments, looking on it only as a group which this little girl could no longer attend. When we learned of the children we wrote the three as new members of our rose court. Before they were examined this little girl was taken ill with a sore throat. Although the doctors did not think it anything serious, she gradually became worse until there was no help for her. The other sisters have not been allowed to lapse but we feel very badly over this misunderstanding."

THIS IS FRIENDSHIP

I love you, not only for what you are, but for what I am when I am with you.

I love you, not only for what you have made of yourself, but for what you are making of me.

I love you for the part of me that you bring out.

I love you for putting your hand in my heaped-up heart and passing over all the frivolous and weak things that you cannot help seeing there, and drawing out into the light all the beautiful, radiant things that no one else had looked quite far enough to find.

I love you for ignoring the possibilities of the fool in me and for laying firm hold of the possibilities of good in me.

I love you for closing your eyes to the discords in me, and for adding to the music in me by worshipful listening.

I love you because you are helping me to make of the lumber of my life, not a tavern, but a temple, and of the words of my every day, not a reproach but a song.

I love you because you have done more than any creed could have done to make me happy.

You have done it without a touch, without a word, without a sign.

You have done it by just being yourself.

Perhaps that is what being a friend means, after all.—Selected.

A Happy

New Year

Seen here is a sample page from the monthly newsletter of the Ladies of the Maccabees.

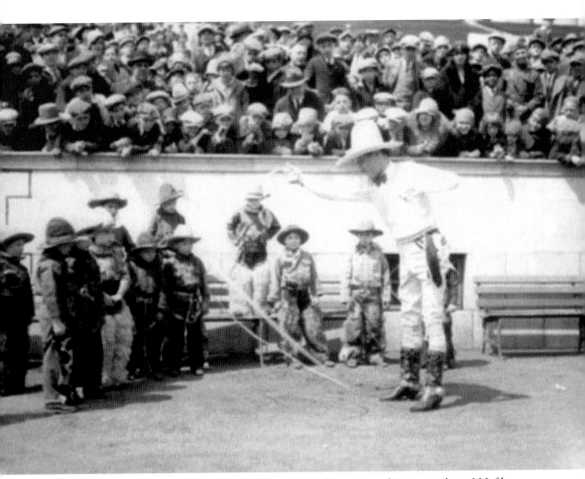

Tom Mix (1880–1940), a Pennsylvania-born actor who appeared in more than 300 films, was the star of many western movies that enthralled millions of American children who grew up watching his cowboy films on Saturday afternoons. Mix reportedly did many of his own stunts in his films and was frequently injured as a result. He was the number one movie cowboy of silent films and was as famous as baseball great Babe Ruth and world champion boxer Jack Dempsey, both of whom were his friends. Here the actor visits Soldier Field in 1928 to demonstrate his skill with the lasso, while spending the day with many of his young fans.

ACTION, ATHLETICS, AND ENTERTAINMENT

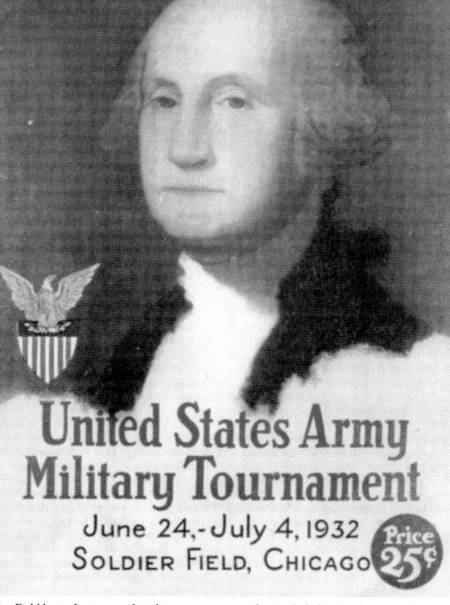

1732 ‖‖ GEORGE WASHINGTON BICENTENNIAL ‖‖ **1932**

United States Army Military Tournament

June 24,–July 4, 1932
SOLDIER FIELD, CHICAGO

Price 25¢

Soldier Field hosted a two-week military tournament that included aerial demonstrations, battle scene and artillery demonstrations, Olympic-course competitions, a parade, and pyrotechnic displays. The venue was tailor-made for such a tournament, as Soldier Field was constructed to honor soldiers and military veterans.

EVENT No. 2
Grand Entry—8:30 P. M.

Commanding Officer:
Major Bird S. Dubois, 61st C. A. C. (AA)

Presentation of all participating troops to the Commanding General.

TROOPS AND MATERIAL:

Infantry, Cavalry, Field Artillery, Machine Gun Units, Anti-Aircraft, Tanks, Armored Cars and Etc.

EVENT No. 3
Animated Tableaux
8:45 P. M.

Director: Mr. F. P. Duffield

George Washington Scenic Spectacle

A review in animated tableaux of outstanding events in and during the life of George Washington.

(a) Boston Tea Party, December 16, 1773.

The beginning of the Revolutionary War.

(b) Washington taking command of the Continental Army.

On July 3, 1775, Washington took command of the Continental Army under the famous Harvard Elm at Cambridge, Mass.

(c) Betsy Ross and the first American Flag.

In June, 1777, Betsy Ross, at Philadelphia, presented to George Washington the design that was accepted by him as the Flag of the Continental Congress.

(d) Washington crossing the Delaware.

On Christmas night, 1776, Washington and his troops crossed the Delaware to Trenton. This perilous journey was one of the crowning feats during the Revolutionary War.

(e) Washington at Valley Forge.

The winter of 1777 was spent by Washington and his troops at Valley Forge. Here, in spite of hardships and suffering, with the assistance of General Von Steuben, he drilled his men and in the following spring won a victory at Monmouth, N. J.

(f) John Paul Jones.

First Admiral of the United States Navy, Commander of the "Bon Homme Rich-

EVENT No. I
Aerial Demonstration
8:00—8:30 P. M.

Commanding Officer, Air Corps:
Major G. E. Brower, Air Corps

Coordinating Officer:
Captain Owen M. Marshburn, 3rd F. A.

Flying Aces of the United States Army Air Corps in thrilling maneuvers and acrobatics, including the spectacular looping Comet, Parachute jumping and combined formations of pursuit, bombardment and observation planes.

Planes From

ELFRIDGE FIELD — 79 Pursuit planes comprising the 18th, 27th, 94th and 36th Pursuit Squadron of 18 planes each and the Head-

A program details myriad events that occurred at the 1932 George Washington Bicentennial

of the Military Tournament

Lafayette so ably assisted our forces in their war with Great Britain.

(h) The Spirit of '76 and 1932.

An allegorical presentation glorifying the indomitable spirit of Washington and founders of our nation, and a call to all patriotic Americans for the protection of our nation today.

EVENT No. 4
Cavalry Demonstration—9:05 P. M.

Officer in Charge:
Captain Thos. G. Hanson, Jr., 14th Cavalry

Intricate drills and maneuvers, featuring Pistol and Saber Charges and Attacks, terminated by daring charges through flaming fire hurdles.

EVENT No. 5
Competition Jumping—9:15 P. M.

Officer in Charge:
Lieut. G. S. Smith, F.A. D.O.L. ADC.

Civilian and U. S. Army entries competing each night over the difficult Olympic Course. Nightly elimination to determine the winner of the Grand Prize on July 4th, the final showing.

EVENT No. 6
Infantry Battalion Parade—9:25 P. M.

Battalion Commander:
Major Paul McDonnell, 2nd Infantry

Fixed bayonets flash as composite battalion of crack Infantry, picked from the Regular Army units of the 2nd Infantry at Fort Wayne, Mich., and Fort Sheridan, Ill., and the 6th Infantry at Jefferson Barracks, Mo., demonstrate the machine-like precision and faultless alignments of well disciplined troops in a battalion parade.

The National Colors formed by 500 members of this unit, flashed across the arena in colorful illumination at the conclusion of this act.

EVENT No. 7
Fort Dearborn Massacre—9:35 P. M.

Director: Mr. F. P. Duffield

Officer in Charge:
Captain Owen M. Marshburn, 3rd Field Artillery

The Attack on Fort Dearborn

On August 15, 1812, a small force of the United States Army decided to evacuate Fort Dearborn, which was located at what is now the southwest corner of Link Bridge in Chicago, in order to join the forces who were resisting the British at

EVENT No. 8
Field Artillery Demonstration
9:45 P. M.

Officer in Charge:
Captain Clifford B. Cole, 3rd F. A.

Horse-drawn 75MM guns in dashing mane and drills at the full gallop, featuring the of guns while moving at high speed, and drills through fire stakes.

EVENT No. 9
Demonstrations by National Grou
10:02 P. M.

June 24th—Navy and French Night.
June 25th—American Legion Night. 75 Star Mothers participating.
June 26th—Hungarian Night.
June 27th—Swiss and Jugo-Slav Night.
June 28th—Scandinavian Night. Danish, wegian and Swedish singers and dancers ticipating.
June 29th—Czechoslovakian Night. Four dred gymnasts participating.
June 30th—Polish Night.
July 1st—Belgian Night.
July 2nd—German Night.
July 3rd—Ukrainian-Lithuanian Night.
July 4th—Italian Night.

EVENT No. 10
Battle Scene—10:17 P. M.

Officer in Charge:
Captain Owen M. Marshburn, 3rd F. A.

The Battle of Cantigny

The scenic set on the north end of the indicates the entrenchments and fortificatio the enemy troops near Cantigny, France, the 1st Division of the United States Arm the first offensive action undertaken by Ame troops, won a valiant victory in the late War where Major General Parker was in comman this presentation all of the army warfare me are presented including the aerial attack and aircraft defense, the barrages by the artillery attack of the infantry and finally the char the cavalry as the fortifications are occupied victorious troops.

EVENT No. 11
Fireworks Display—10:24 P. M

Director: Mr. F. P. Duffield

Military Tournament.

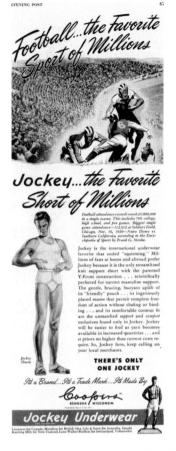

Football may have been the favorite sport of millions, but Jockey underwear was apparently the favorite short of millions, as indicated by this early advertisement that employs statistics from football attendance at Soldier Field, where proper support is critical. Pictured below is a Soldier Field postcard from the late 1920s illustrating an early view of the stadium's interior. In its original configuration, spectator seating reached the low points of the colonnades.

204:—Soldiers' Field, Chicago, Ill.

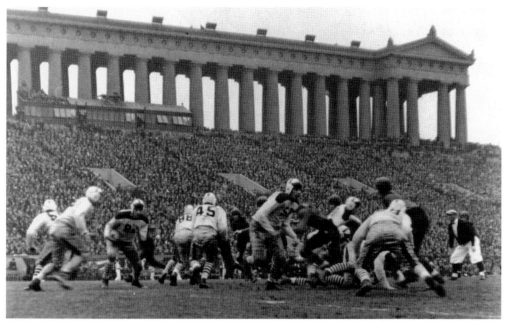

Two vintage photographs (above and below) show the Chicago Bears as guests at Soldier Field during an early-1930s game. Note the antiquated look of the players' uniforms at a time when athlete uniforms did not possess the high-quality safety features common to the uniforms of today. Four decades later, in 1971, the Bears made Soldier Field their permanent home.

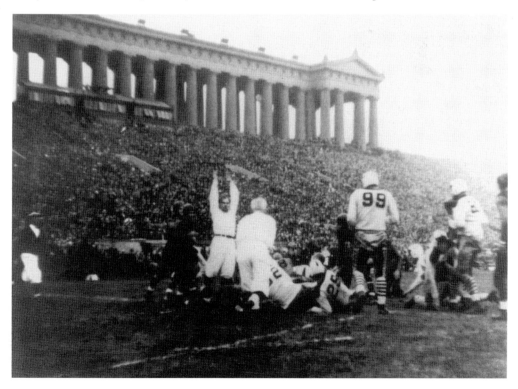

GREAT SPECTATOR SPORT—

At Soldiers' Field—Chicago

Excitement makes a game. But in between exciting moments a man needs soothing, satisfying things—and that's where Cinco comes in. Extra flavor—extra aroma—extra care in blending—have made this smoke a spectator's favorite. Yes, Cinco's popularity is gaining everywhere—with men who know its outstanding quality.

A PRODUCT OF THE WEBSTER TOBACCO COMPANY, INC., N. Y.

CINCO MEANS FIVE

1 Havana—*gives Cinco aroma.*
2 Puerto Rican—*gives it flavor and mildness.*
3 Broadleaf—*gives it mellowness.*
4 Shadegrown—*gives it character.*
5 100% long filler—*makes it burn slowly, evenly.*

Try Cinco—you'll see—it's worth a darn sight more than its low price

THAT GOOD AMERICAN CIGAR **11¢**

This 1946 advertisement purports that the flavor and aroma of a Cinco cigar will only add to the excitement and satisfaction of a game at "Soldiers' Field."

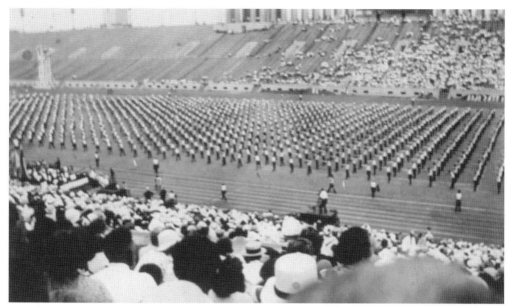

Spectators observe an unidentified formation at Soldier Field in this 1940s/1950s photograph.

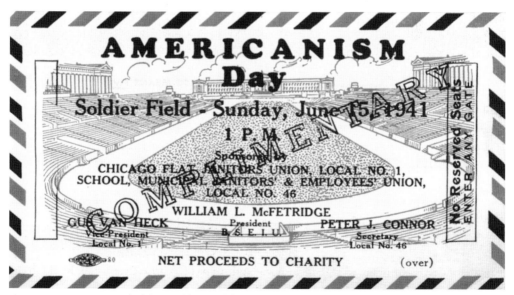

Americanism Day was held at Soldier Field on June 15, 1941, for the janitors' unions. The event included the United States Drum and Bugle Corps, the American Legion Bands, high school and ROTC bands and drill teams, and the promise of one star "of screen, stage or radio."

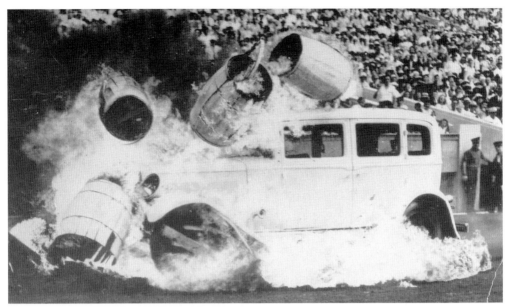

Decades before the controversial MTV program *Jackass* and prior to the evolution of NASCAR racing, human daredevil "Lucky" Lee Lott, a native of Pekin, Illinois, laid to rest 17,981 cars during his career as a stunt car driver with his famous "Hell Drivers." In the 1939 photograph above, Lott performs a barrel wall crash, plowing the vehicle through flaming barrels in front of 98,000 spectators at Soldier Field. Pictured below is a 1939 photograph of Hell Driver Al Perry riding the hood of a vehicle driving through a blazing one-inch-thick board wall at Soldier Field. Known as "the human battering ram," this stunt featured Lott at the wheel as Perry endured the heat outside.

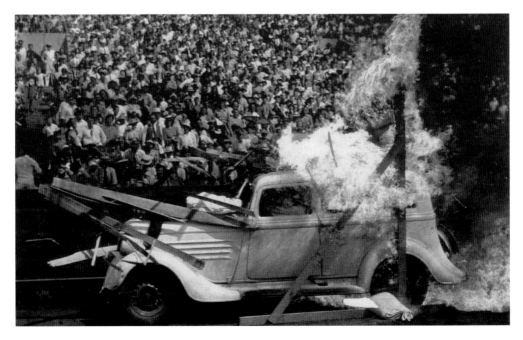

ACTION, ATHLETICS, AND ENTERTAINMENT

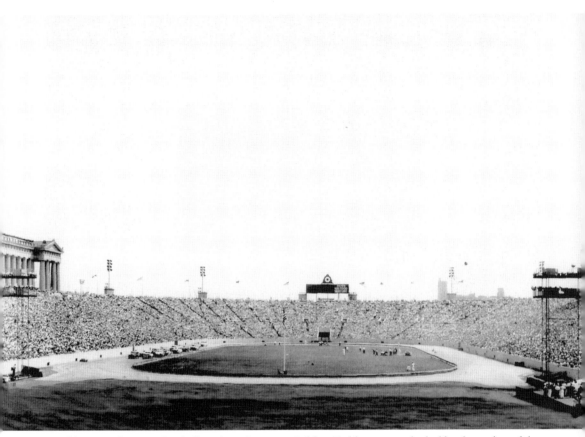

In addition to hosting football and track meets, Soldier Field contained a half-mile oval used for stock car, midget automobile, and motorcycle racing. Stock car racing became something of a new national pastime during the summer months as two dozen souped-up Fords, Chevrolets, and Plymouths careened against each other on the quarter-mile track. The racetrack was torn out in 1970. (Courtesy of Tiger Tom Pistone.)

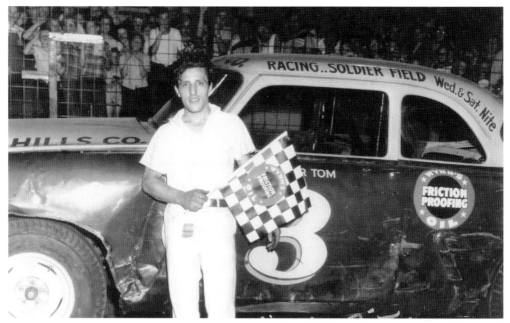

"Tiger" Tom Pistone began his stock car racing career in the 1940s at Soldier Field and won the track title there in the 1950s, capturing the crown five consecutive times. Pistone established Tiger Tom Pistone Race Cars and Parts in 1950, supplying parts and building cars for the NASCAR Grand National Division, Winston Cup Series, Busch Grand National Series, and Craftsman Truck Series. (Courtesy of Tiger Tom Pistone.)

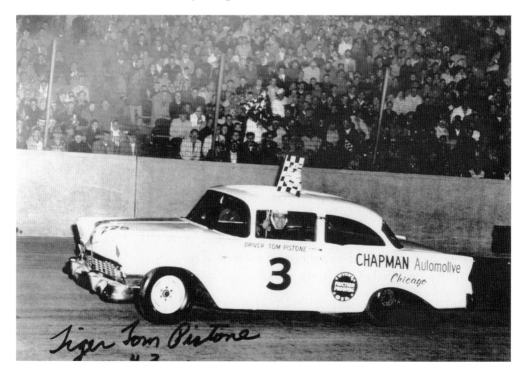

DATE	EVENT	DATE	EVENT
2 June (Sat.)	11th ANNUAL GOLD TROPHY STOCK CAR RACES	25 Aug. (Sat.)	Stock Car Races
9 June (Sat.)	Opening Stock Car Races	25 Aug. thru 3 Sept. (10 days)	RINGLING BROS. CIRCUS
16 June (Sat.)	Stock Car Races	21 Sept. (Fri.)	ARMED FORCES FOOTBALL GAME
23 June (Sat.)	Stock Car Races		
23 June (Sat.) 24 June (Sun.)	SANTA FE HI-LEVEL "EL CAPITAN" EXHIBIT	22 Sept. (Sat.)	Rain Date for Above
27 June (Wed.)	JOIE CHITWOOD THRILL SHOW	28 Sept. (Fri.)	C.V.S. vs. Phillips High School
		30 Sept. (Sun.)	De LaSalle vs. Mt. Carmel
28 June (Thurs.)	Rain Date for Above	14 Oct. (Sun.)	Mt. Carmel vs. St. Rita
30 June (Sat.)	Stock Car Races	19 Oct. (Fri.)	DuSable vs. Dunbar High School
4 July (Wed.)	ANNUAL FOURTH OF JULY CELEBRATION	28 Oct. (Sun.)	St. George vs. Weber High School
5 July (Thurs.)	Rain Date for Above	2 Nov. (Fri.)	Public High School Playoffs
7 July (Sat.)	Stock Car Races	3 Nov. (Sat.)	Public High School Playoffs
14 July (Sat.)	Stock Car Races	9 Nov. (Fri.)	Public High School Quarterfinals
20 July (Fri.)	NEWBERRY THRILL SHOW	10 Nov. (Sat.)	Public High School Quarterfinals
21 July (Sat.)	Stock Car Races	11 Nov. (Sun.)	Catholic High School Quarterfinals
28 July (Sat.)	Stock Car Races	17 Nov. (Sat.)	Public High School Semi-finals
4 Aug. (Sat.)	Stock Car Races	18 Nov. (Sun.)	Catholic High School Semi-finals
10 Aug. (Fri.)	23rd ANNUAL ALL-STAR FOOTBALL GAME	24 Nov. (Sat.)	Public High School Championship
11 Aug. (Sat.)	Rain Date for Above	25 Nov. (Sun.)	Catholic High School Championship
18 Aug. (Sat.)	27th ANNUAL CHICAGOLAND MUSIC FESTIVAL	1 Dec. (Sat.)	INTER-LEAGUE CHAMPIONSHIP GAME
19 Aug. (Sun.)	Rain Date for Above		*(Mayor Daley's Youth Foundation Benefit)*

A schedule of 1956 events at Soldier Field included stock car races, a Fourth of July celebration, a music festival, the circus, and several high school football games. The stadium, which was not limited to professional football games, was well used for a variety of events over a six-month period.

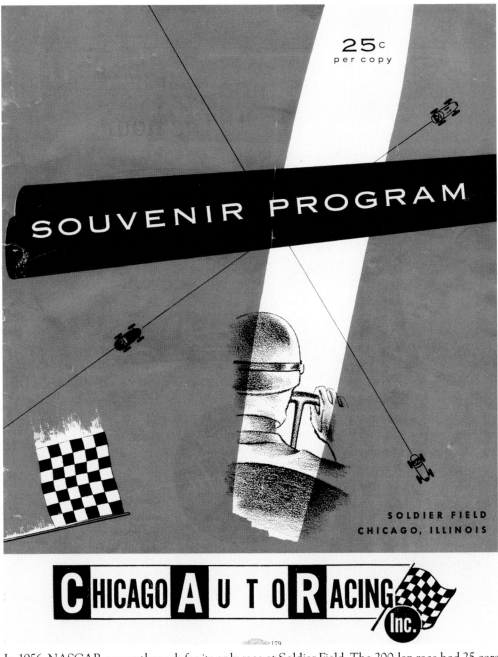

In 1956, NASCAR swung through for its only race at Soldier Field. The 200-lap race had 25 cars participating in it, with Fireball Roberts averaging 61.037 miles per hour to win $850. Pictured above is a souvenir program cover.

ACTION, ATHLETICS, AND ENTERTAINMENT

STOCK CAR STUTTERS

By "Shorty" Fall

Here we are at Chicagoland's first "500" and our final race of the year here in Soldier Field. It seems only a short time ago that these convertibles were here and Tom Pistone, three time Soldier Field stock car champion, over took Curtis Turner in the final eight laps of the one hundred lap go-round to win. However all of the drivers tonight will have their work cut out for them for Turner won the 500 mile race at Darlington on Labor Day before 75,000 people.

This afternoon the top name drivers in the NAS-CAR Convertible Division will wheel the manufacturers latest convertibles 500 times around this ½ mile track in Chicago's biggest auto race to ring down the curtain for this year, however, there are rumors afloat that there might be racing indoors in the International Amphitheatre in November or December. If you are not on our mailing list and want to be informed write to Chicago Auto Racing, Inc., Gate "O" Soldier Field, Chicago, Ill.

We have had numerous honors bestowed upon our drivers and officials but one of the highest was awarded to our track physician Dr. Walter Prusait of 4333 W. North Ave. He was voted the high honor of Surgeon General of the Veterans of Foreign Wars of the United States at Dallas, Texas, last week. He has been department Surgeon for the State of Illinois for the past two years and prior to that time has been very active in Veterans' affairs. Congratulations "DOC".

The two beautiful 1956 Ford Convertible pace cars in which the queens will ride are furnished through the courtesy of two of Chicago's outstanding Ford dealers, Jim Moran, 3579 West Grand and Litzinger Motors, 1200 West Washington.

All cars in today's Chicagoland "500" are powered by the famous Power X gasoline by the Sinclair Refining Co. The exclusive additive used today is Wynn's Friction Proofing furnished through the courtesy of Wynn's Oil Co.

Lap prize money this afternoon will be awarded by Warshawski & Co. the original dealers of accessories who will give the leader at 100 laps the first of the $100 prize monies. Polk Brothers will give $100 to the leader at 250 laps, Chez Paree $100 dollars for the leader at 300 and Nelson-Hirschberg the leader at 400. It makes a tidy sum for the boys who are out in front.

The timing for the races this afternoon will be done by the Precision Timing Co. of Cincinnati, Ohio.

We hope all of you folks will be thrilled by the biggest auto race in Chicago's history and will give the drivers a great big hand.

This is "Shorty" Fal signing off for the season.

Pictured are an essay detailing the action and a list of the NASCAR racers.

CHICAGOLAND'S FIRST "500"
NASCAR CONVERTIBLE—INTERNATIONAL

	DRIVER	HOME	CAR	POINTS	CAR NO.
1.	Bob Welborn	Greensboro, N. C.	'56 Chev. V-8	5420	
2.	Larry Odo	Chicago, Ill.	'56 Chev. V-8	5198	
3.	Curtis Turner	Roanoke, Va.	'56 Ford V-8	4936	
4.	Don Oldenberg	Highland, Ind.	'55 Buick Century	4550	
5.	Mel Larson	Phoenix, Ariz.	'56 Ford V-8	4288	
6.	Art Binkley	Louisville, Ky.	'56 Plym. V-8	3896	
7.	Dave Hirschfield	Birmingham, Ala.	'55 Chev. V-8	3146	
8.	Larry Frank	Indianapolis, Ind.	'56 Mercury	3014	
9.	Frank Mundy	Atlanta, Ga.	'56 Dodge D-500	2058	
10.	Jimmy Thompson	Monroe, N. C.	'56 Mercury	2050	
11.	Jim Massey	Burlington, N. C.	'56 Chev. V-8	1692	
12.	Dick Joslin	Orlando, Fla.	'56 Dodge D-500	1656	
13.	Gene Blair	Buffalo, N. Y.	'56 Mercury	1652	
14.	Allen Adkins	Fresno, Calif.	'56 Dodge D-500	1582	
15.	"Possum" Jones	Mango, Fla.	'56 Chev. V-8	1338	
16.	Danny Letner	Downey, Calif	'56 Dodge D-500	1516	
17.	Bill Brown	Roseland, Ill.	'56 Mercury	1456	
18.	Roy Atkinson	Indianapolis, Ind.	'56 Dodge D-500	1288	
19.	Marvin Panch	Gardena, Calif.	'56 Dodge D-500	1280	
20.	Bill Lutz	Louisville, Ky.	'56 Ford V-8		
21.	Jimmy Lewallen	Winston-Salem, N. C.	'56 Chev. V-8		
22.	Gwin Staley	Greensboro, N. C.	'56 Chev. Corvette		
23.	Joe Weatherly	Norfolk, Va.	'56 Ford		
24.	Glen Woods		'56 Ford V8		

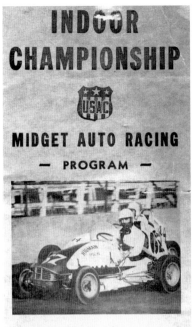

INDOOR CHAMPIONSHIP

USAC

MIDGET AUTO RACING

— PROGRAM —

Saturday Night, January 14th

This Program Compliments Of:

RUPERT SAFETY BELTS

Midget automobile racing was considered by some to be the purest form of auto racing because a racer employed only four wheels, a four-cylinder engine, a fuel tank, and a seat. This 1961 program (above and below) details the racers as well as the "pit patter" that people wanted to read about at the time.

=== *Pit Patter* ===

By BILL WILSON

The USAC boys are really getting down to business tonight as the 1961 indoor season reaches the halfway mark and points are starting to pile up for the crown. Bob McLean is defending his title against some of the toughest competition in the racing world with stars like "Chuck" Rodee, former indoor champ; Rex Easton, Danny Khdis, Gene Hartley, Bob Wente, Dick Northam, Chuck Weyant and Bob Ellingham gunning for the crown.

Many of the above named also drive in the annual Memorial Day classic 500-miler at Indianapolis. "Nothing," the boys claim, "keeps a guy sharp for the big cars as driving these hot rocks on indoor tracks during the long winter months."

Rex Easton, who just recently returned to racing to racing after a long siege in the hospital, is rarin' to go tonight, The Lloyd Rahn Offy he drove here on December 17th has

been re-worked for indoor-type competition. Rex grabbed off a fourth in the feature last time out on this floor.

Prior to tonight's race, the boys, girls and men from Go-Kart Club of America ran a thrilling series of heat and elimination races this afternoon. They will return tomorrow for a series of features in all classes.

They run in Classes "A", "A standard", "A Super", "B", "B Super", "C" and "C Super". Many of the karts raced in the international events at Nassau, BWI, and will be back here for the World's Indoor Championships on March 25 and 26.

That same date marks the opening of Chicago's annual Rod & Custom car show. Last year, over 100 of the nation's top Rods and Customs were on display and at least double that number is expected this year.

DON'T FORGET.....after tonight the USAC midgets return on February 4th and again in the season wind-up on March 25th.

COME ONE, COME ALL . . . **AND BRING YOUR FRIENDS!**

Here are more details from the midget racing program.

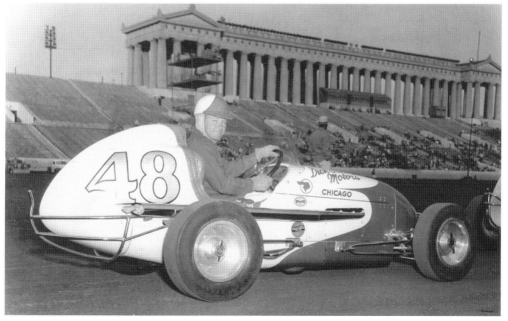

This 1948 photograph features racer Johnny Smith, who was a staple in the midget automobile racing circuit. (Photograph by Armin Krueger.)

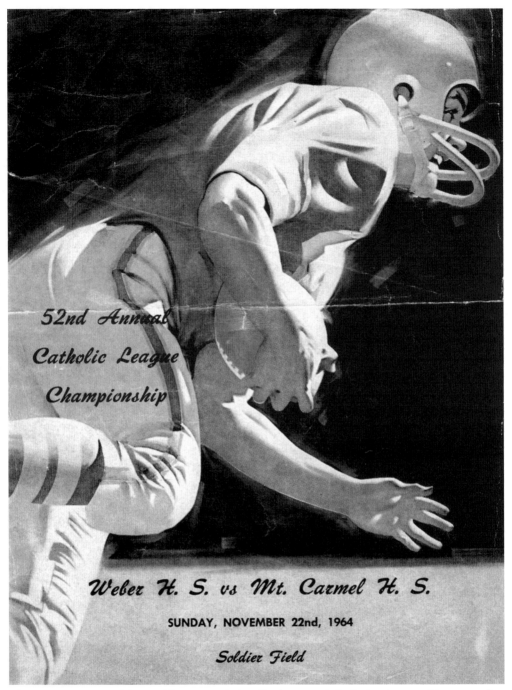

52nd Annual
Catholic League
Championship

Weber H. S. vs Mt. Carmel H. S.

SUNDAY, NOVEMBER 22nd, 1964

Soldier Field

The year 1964 at Soldier Field witnessed the 52nd Annual Catholic League Championship between Weber and Mount Carmel.

ACTION, ATHLETICS, AND ENTERTAINMENT

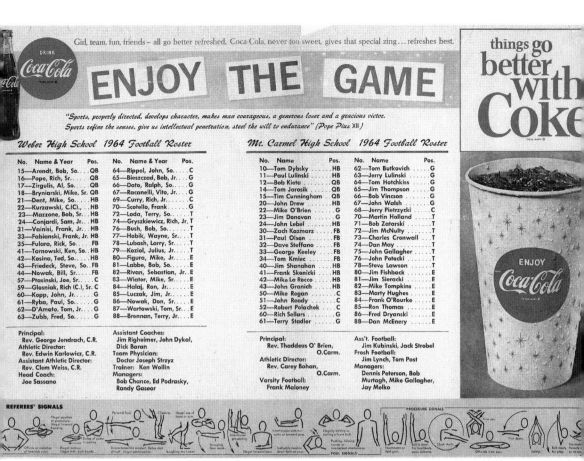

"Sports, properly directed, develops character, makes man courageous, a generous loser and a gracious victor. Sports refine the senses, give us intellectual penetration, steel the will to endurance" (Pope Pius XII)

Weber High School 1964 Football Roster

No.	Name & Year	Pos.	No.	Name & Year	Pos.
15	Arendt, Bob, So.	QB	64	Rippel, John, So.	C
16	Pope, Rich, Sr.	QB	65	Bieszczad, Bob, Jr.	G
17	Zirgulis, Al, So.	QB	66	Dato, Ralph, So.	G
18	Bryniarski, Mike, Sr.	QB	67	Racanelli, Vito, Jr.	G
21	Dent, Mike, So.	HB	69	Curry, Rich, Jr.	C
22	Kurzawski, C.(Cl.),	HB	70	Scotello, Frank	G
23	Mazzone, Bob, Sr.	HB	72	Loda, Terry, So.	T
24	Conjardi, Sam, Jr.	HB	74	Gryszkiewicz, Rich, Jr.	T
31	Vainisi, Frank, Jr.	HB	76	Bush, Bob, So.	T
33	Fabianski, Frank, Jr.	HB	77	Hobik, Wayne, Sr.	T
35	Fulara, Rick, So.	FB	78	Lubash, Larry, Sr.	T
41	Tarnowski, Ken, So.	HB	79	Koziol, Julius, Jr.	T
42	Kosina, Ted, So.	HB	80	Figura, Mike, Jr.	E
43	Friedeck, Steve, So.	FB	81	Labbe, Bob, So.	E
44	Nowak, Bill, Sr.	FB	82	Rivan, Sebastian, Jr.	E
57	Ptasinski, Joe, Sr.	C	83	Wiater, Mike, Sr.	E
59	Glosniak, Rich (C.), Sr.	C	84	Halaj, Ron, Jr.	E
60	Kopp, John, Jr.	G	85	Luczak, Jim, Jr.	E
61	Ryba, Paul, So.	G	86	Nowak, Don, Sr.	E
62	D'Amato, Tom, Jr.	G	87	Wartowski, Tom, Sr.	E
63	Zubb, Fred, So.	G	88	Brennan, Terry, Jr.	E

Principal:
Rev. George Jendrach, C.R.
Athletic Director:
Rev. Edwin Karlowicz, C.R.
Assistant Athletic Director:
Rev. Clem Weiss, C.R.
Head Coach:
Joe Sassano

Assistant Coaches:
Jim Righeimer, John Dykal, Dick Baran
Team Physician:
Doctor Joseph Strzyz
Trainer: Ken Wollin
Managers:
Bob Chance, Ed Podrasky, Randy Gaseor

Mt. Carmel High School 1964 Football Roster

No.	Name	Pos.	No.	Name	Pos.
10	Tom Dybsky	HB	62	Tom Butkovich	G
11	Paul Lulinski	HB	63	Jerry Lulinski	G
12	Bob Kieta	QB	64	Tom Hotchkiss	G
14	Tom Jarosik	QB	65	Jim Thompson	G
15	Tim Cunningham	QB	66	Bob Vincson	G
20	John Drew	HB	67	John Walsh	G
22	Mike O'Brien	G	68	Jerry Pietrzycki	C
23	Jim Donovan	G	70	Martin Holland	T
24	John Lebel	HB	71	Bob Zatarski	T
30	Zach Kazmarz	FB	72	Jim McNulty	T
31	Paul Olsen	FB	73	Charles Cronwall	T
32	Dave Steffano	FB	74	Dan May	T
33	George Keeley	FB	75	John Gallagher	T
34	Tom Kmiec	FB	76	John Potacki	T
40	Jim Shanahan	HB	78	Steve Lawson	T
41	Frank Skonicki	HB	80	Jim Fishback	E
42	Mike La Rocco	HB	81	Jim Sieracki	E
43	John Granich	HB	82	Mike Tompkins	E
50	Mike Regan	C	83	Marty Hughes	E
51	John Ready	C	84	Frank O'Rourke	E
52	Robert Polachek	C	85	Ron Thomas	E
60	Rich Sellars	G	86	Fred Dryanski	E
61	Terry Stadler	G	88	Dan McEnery	E

Principal:
Rev. Thaddeus O'Brien, O.Carm.
Athletic Director:
Rev. Carey Bohan, O.Carm.
Varsity Football:
Frank Maloney

Ass't. Football:
Jim Kubinski, Jack Strobel
Frosh Football:
Jim Lynch, Tom Post
Managers:
Dennis Peterson, Bob Murtagh, Mike Gallagher, Jay Melko

ENJOY Coca-Cola

REFEREES' SIGNALS

The players and coaches of the day are listed above.

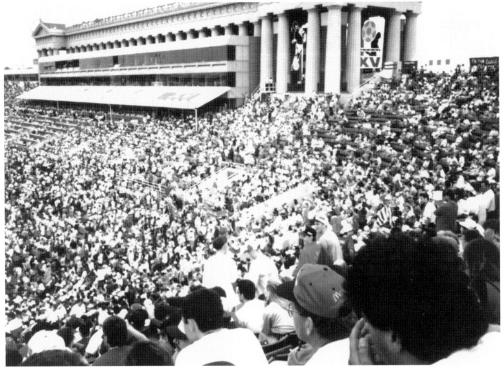

When the Federation of International Football Associations (FIFA) chose the United States as the setting of the 1994 World Cup, the organization did so with the hope that by staging the world's premier soccer tournament there, it would lead to America's growth of interest in soccer. FIFA's gamble paid off as average attendance was 69,000 with more than 3.5 million attending the final tournament, thus setting a historical record. Bulgaria and Greece squared off at Soldier Field on June 26, 1994, with the stadium filled to capacity. Although the stadium's stands were honeycombed with fans adorned in blue and white, Bulgaria edged out Greece with a score of 4-0. (Courtesy of John Pearson.)

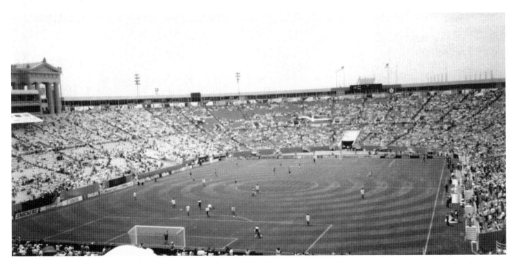

ACTION, ATHLETICS, AND ENTERTAINMENT

4

NOTABLE VISITORS

By profession I am a soldier and take pride in that fact. But I am prouder—infinitely prouder—to be a father. A soldier destroys in order to build; the father only builds, never destroys. The one has the potentiality of death; the other embodies creation and life. And while the hordes of death are mighty, the battalions of life are mightier still. It is my hope that my son, when I am gone, will remember me not from the battle but in the home repeating with him our simple daily prayer,
'Our Father, who art in heaven.'

—Gen. Douglass MacArthur

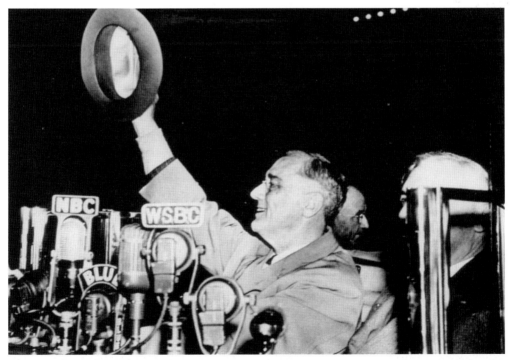

Pres. Franklin Delano Roosevelt paid a wartime visit to Soldier Field in October 1944. (Courtesy of the Franklin D. Roosevelt Library, Hyde Park, New York.)

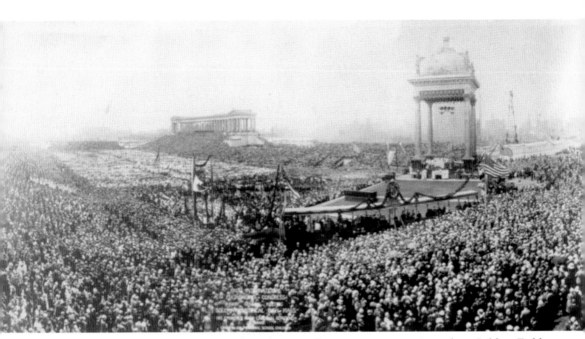

On June 21, 1926, the International Eucharistic Congress mass was staged in Soldier Field. Featuring a 62,000-member children's choir, the five-day event drew more than 500,000 Catholics from around the world. The Eucharistic Congresses offered Catholics the opportunity to proclaim their faith in public demonstration, to show openly their devotion to the Holy Eucharist at an open-air mass. Daily newspaper accounts from that time reported crowds so massive they overstrained the three lines of steam railroads connecting Mundelein to the city as well as electric transport facilities. One daily paper reported the event as "the greatest religious spectacle witnessed by the western world, the most colossal prayer meeting in the authentic annals of Christendom."

NOTABLE VISITORS

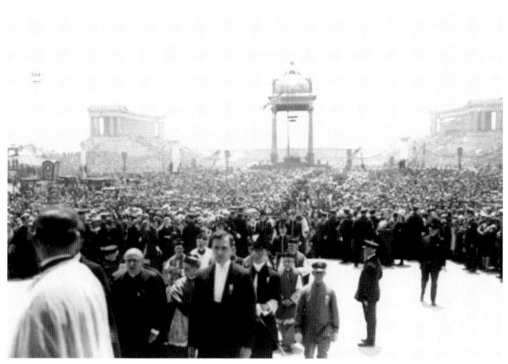

Pictured above and below are the opening procession and a photograph of Cardinal John Bonzano preparing for the mass with other clergy.

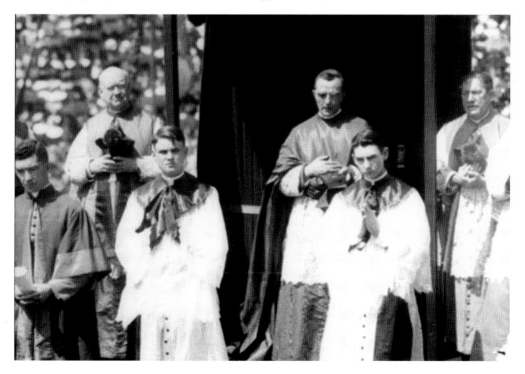

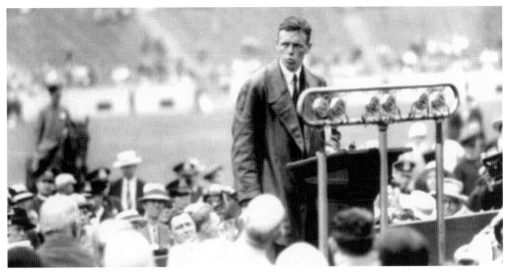

When Charles Lindbergh completed his successful transatlantic flight, Col. Robert McCormick invited him to Chicago, where Colonel McCormick staged a huge public reception for him at Soldier Field. Elinor Smith Sullivan, winner of the 1930 Best Woman Aviator of the Year Award, described the impact Lindbergh had on aviation. Before his flight, Sullivan remembered that "people seemed to think we aviators were from outer space or something. But after Charles Lindbergh's flight, we could do no wrong. It's hard to describe the impact Lindbergh had on people. Even the first walk on the moon doesn't come close. The twenties was such an innocent time, and people were still so religious—I think they felt like this man was sent by God to do this. And it changed aviation forever because all of a sudden the Wall Streeters were banging on doors looking for airplanes to invest in. We'd been standing on our heads trying to get them to notice us but after Lindbergh, suddenly everyone wanted to fly, and there weren't enough planes to carry them."

In 1944, 150,000 spectators attended a wartime visit by Pres. Franklin Roosevelt at Soldier Field. Roosevelt was the 32nd president of the United States. Elected to four terms in office, he served from 1933 to 1945. In this address, delivered six months prior to the end of the war and six months prior to his death, Roosevelt ended his speech with these words: "I believe in our democratic faith. I believe in the future of our country, which has given eternal strength and vitality to that faith. Here in Chicago you know a lot about that vitality. And as I say good night to you, I say it in a spirit of faith—a spirit of hope—a spirit of confidence. We are not going to turn the clock back! We are going forward, my friends—forward with the fighting millions of our fellow countrymen. We are going forward together."

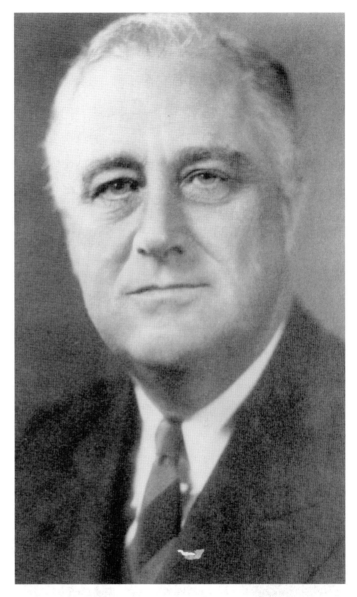

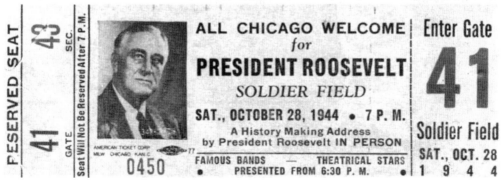

RESERVED SEAT
SEC. 43
41
GATE
Seat Will Not Be Reserved After 7 P. M.

AMERICAN TICKET CORP.
MILW CHICAGO KAN.C
77
0450

ALL CHICAGO WELCOME
for
PRESIDENT ROOSEVELT
SOLDIER FIELD
SAT., OCTOBER 28, 1944 • 7 P. M.
A History Making Address
by President Roosevelt IN PERSON
FAMOUS BANDS — THEATRICAL STARS
PRESENTED FROM 6:30 P. M.

Enter Gate
41
Soldier Field
SAT., OCT. 28
1 9 4 4

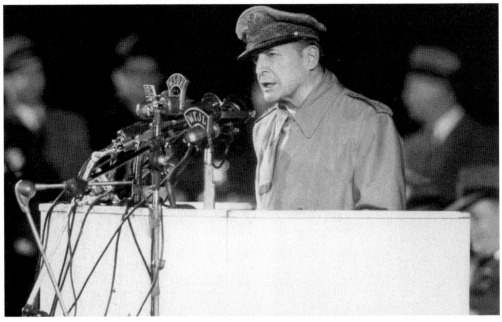

Gen. Douglas MacArthur—on his first visit to the United States in 14 years—addressed an audience of 50,000 at Soldier Field in April 1951. Although MacArthur was a brilliant military strategist, his ego and criticism of White House policy led to his dismissal by Pres. Harry Truman on April 11, 1951. Noted historian David McCullough observed about MacArthur, "There was nothing bland about him, nothing passive about him, nothing dull about him. There's no question about his patriotism, there's no question about his courage, and there's no question, it seems to me, about his importance as one of the protagonists of the 20th century."

"LET EVERY NATION KNOW, WHETHER IT WISHES US WELL OR ILL, THAT WE SHALL PAY ANY PRICE, BEAR ANY BURDEN, MEET ANY HARDSHIP, SUPPORT ANY FRIEND, OPPOSE ANY FOE TO ASSURE THE SURVIVAL AND THE SUCCESS OF LIBERTY."

JOHN FITZGERALD KENNEDY

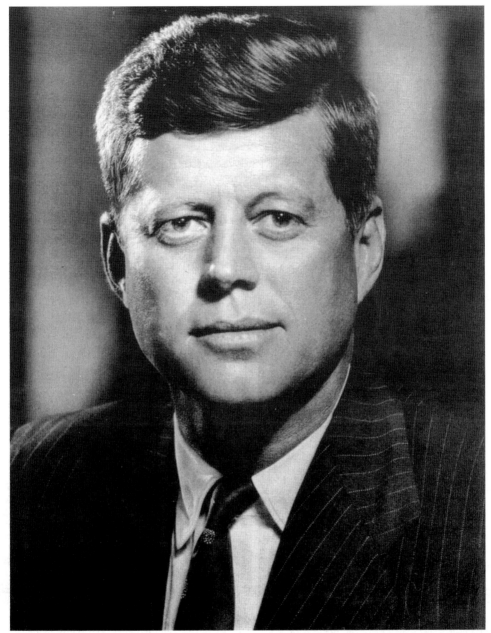

Prior to the fateful Dallas trip, Pres. John F. Kennedy had been scheduled to attend the Army-Air Force football game at Soldier Field in Chicago on November 2, 1963. President Kennedy's planned football game attendance was abruptly canceled as crowds were already gathering to greet him. Some time after his death only 20 days later, the reason for the Soldier Field cancellation indicated that the Secret Service received word of a possible assassination attempt. Today an excerpt of Kennedy's enduring words (pictured at left) from his 1961 inaugural address greet visitors at the north end of Soldier Field's walkway. The John F. Kennedy War Memorial was dedicated to veterans at a ceremony on Veteran's Day 2003.

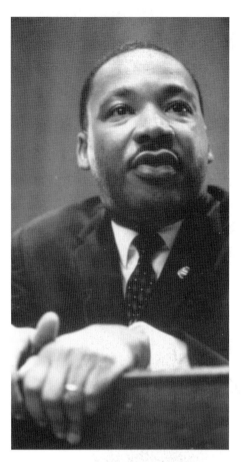

On July 10, 1966, Dr. Martin Luther King Jr., a Baptist minister and political activist who was one of the main leaders of the American civil rights movement, addressed a crowd of more than 50,000 at Chicago's Soldier Field during the campaign to end slums in Chicago. In his 1987 work, *An Autobiography of Black Politics*, author Dempsey Travis wrote that at the end of his speech, King led 38,000 of his followers on a march from Soldier Field to city hall, where he posted demands of the Non Violent Freedom Fighters on Mayor Richard J. Daley's door. This echoed the actions of his namesake, Martin Luther (a 16th-century Lutheran theologian) who nailed his 95 theses on the door of the Castle Church in Wittenberg, Germany, on October 31, 1517, resulting in the Protestant Reformation. This civil rights crusade, known as the Freedom Rally, later prompted a summit meeting between Daley and King at the Palmer House Hotel. On July 31, 1968, the Chicago City Council honored King by changing the name of South Park Way to Martin Luther King Jr. Drive. A pictorial collage that hangs in Soldier Field today includes a view of the 1966 rally (pictured below).

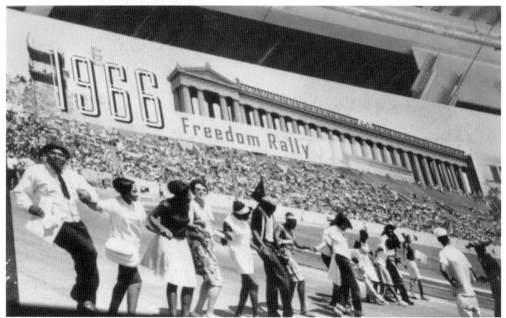

NOTABLE VISITORS

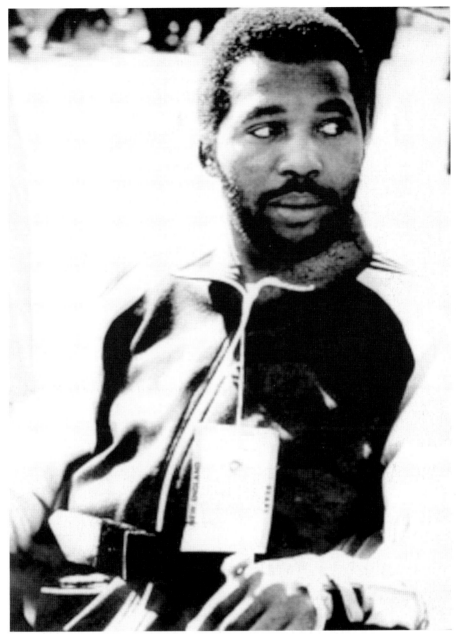

Darryl Stingley (1951–2007), a wide receiver who attended Purdue University on a scholarship, was a first-round draft pick of the New England Patriots in 1973. Although Stingley's five-year professional football career was cut short by a serious injury in 1978, his life continued to exemplify courage, grace, and vitality. He later served for many years as the executive director of player personnel for the New England Patriots, authored a memoir of his life titled *Happy to Be Alive*, and began a nonprofit organization to service the needs of at-risk youth in Chicago. In the photograph above, Darryl Stingley visits Soldier Field during a Chicago Bears–New England Patriots game on October 14, 1979.

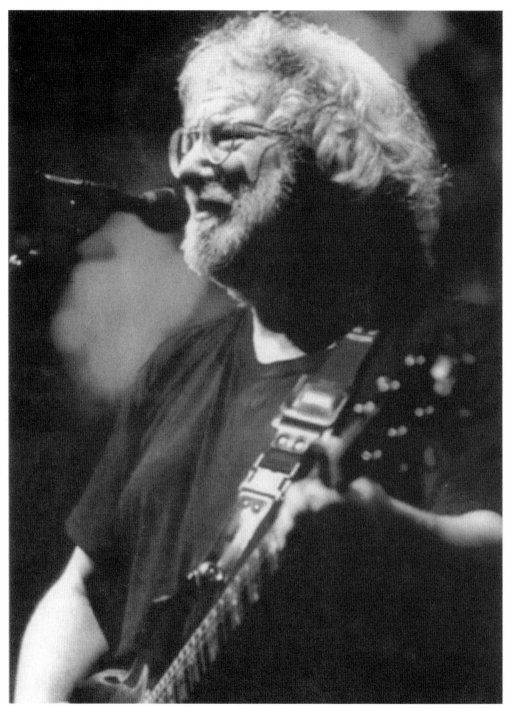

On July 9, 1995, Jerry Garcia and the Grateful Dead performed their 2,314th and final concert at Soldier Field. The last songs performed were a medley of "Black Muddy River" and "Box of Rain." Exactly one month later, Garcia succumbed to a heart attack at age 53, after having checked into a drug rehabilitation facility in Forest Knolls, California.

South African musical export Dave Matthews catered to 170,000 fans over two nights at Soldier Field in July 2001. Matthews did his best to temper any anxiety he may have felt playing in such an overwhelming venue: "This place is big, and I'm kind of nervous," Matthews remarked, "so we're going to make it feel small by pretending were in a . . . bedroom. We'll hang off the edge of the bed and take off our shoes."

On July 21, 2006, Jon Bon Jovi performed for three straight hours in his "Have a Nice Day" tour for 60,000 fans at Soldier Field. This was the stadium's longest-running music concert. In a 2006 interview with *Chicago Sun-Times* journalist Miriam Di Nunzio, Bon Jovi shared his thoughts about keeping concert ticket prices down: "We are very aware of ticket prices when we set up a tour. We don't do a cheap ticket, but we do a very fair ticket price. Forget about the cost of a concert ticket, I'm very aware of the cost of living. I can't dispute what the Stones or Madonna wanna charge, but I know that to take a date to a concert, park the car, get a T-shirt, buy a couple of beers—that's more than a week's pay for a lot of folks. We charge less and know that 50,000 seats will be sold for Soldier Field. That's just good business."

NOTABLE VISITORS

THE SPECIAL OLYMPICS

Let me win. But if I cannot win, let me be brave in the attempt.

—Special Olympics Athletic Oath

The Special Olympics began in Illinois, as the first games were held at Soldier Field on July 20, 1968, when 1,000 children between the ages of 8 and 18 came together from around the United States and Canada to participate in athletic competitions that had never before been offered to children and adults with intellectual disabilities. Individuals who were instrumental in creating and shaping the Special Olympics include Dr. William Freeberg (who was then chairman of the Department of Recreation at Southern Illinois University in Carbondale), Eunice Kennedy Shriver and the Joseph P. Kennedy Jr. Foundation, and Anne McGlone Burke (then a recreation teacher from the Chicago Park District and now a justice of the Illinois Appellate Court). Pictured above is a group of dignitaries, including Mayor Richard J. Daley at the far right, who oversaw and attended the event.

Workers and athletes prepare the field for competition. Events included track and field, aquatics in four different ability levels, and floor hockey. (Courtesy of Special Olympics.)

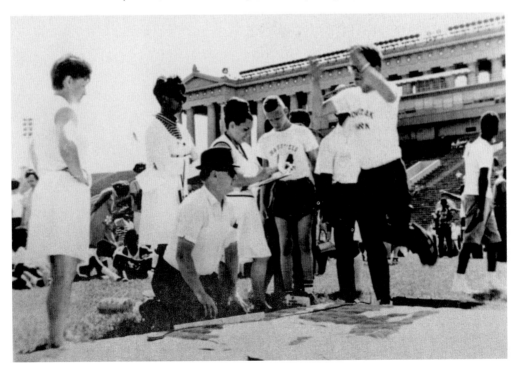

　　　　　　　　　　　　　　　　　THE SPECIAL OLYMPICS

Stadium personnel light the "Flame of Hope" in 1968 (right) and in 2007 (below) at the opening ceremonies of the 39th Annual Special Olympics in Chicago. (Right, courtesy of Special Olympics.)

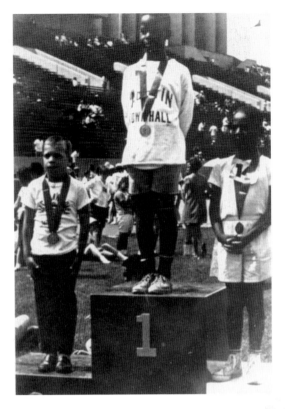

Proud Special Olympics athletes receive their medals in the first events of the Special Olympics in 1968. (Courtesy of Special Olympics.)

Local programs are coordinated throughout 17 geographic areas:

3 - City of Chicago
5 - Suburban Cook
7 - South Cook-Will
18 - Northwest Suburban

A map from Special Olympics Illinois illustrates the program's expansion as of 2007.

During the presentation of colors, Wayne Messmer sings the National Anthem at the opening ceremonies of the 39th Annual Special Olympics.

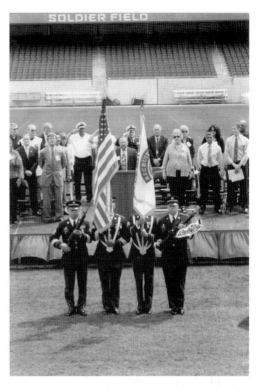

Staley the Bear entertains spectators prior to the presentation of the Magnuson Award at the 2007 opening ceremonies.

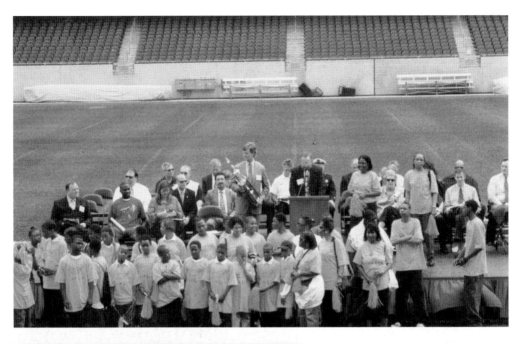

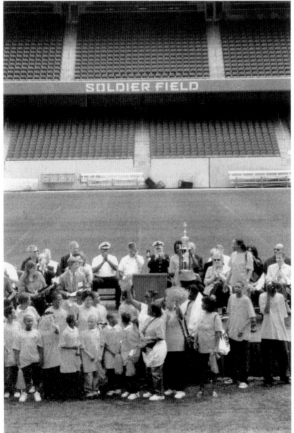

The Keith Magnuson Spirit Award is presented to the team that had modeled the mission of Special Olympics by "encouraging physical fitness, demonstrating courage, experiencing joy and participating in the sharing of gifts, skills and friendship with their families, community and other Special Olympics athletes throughout the calendar year." The award has been presented annually since 1988. The 2007 Spirit Award recipient was D. S. Wentworth School through the efforts of Ophelia Doyle, the head coach. In the photographs above and at left, Doyle accepts the Spirit Award from master of ceremonies Kevin Magnuson as throngs of her athletes look on in proud recognition.

THE SPECIAL OLYMPICS

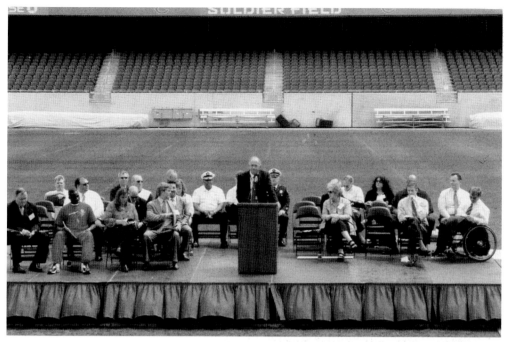

In the photograph above, president and CEO of Special Olympics Illinois Doug Snyder addresses the participants and spectators of the 2007 opening ceremonies. Pictured below are the Jesse White Tumblers entertaining the crowd with thrilling feats of acrobatics.

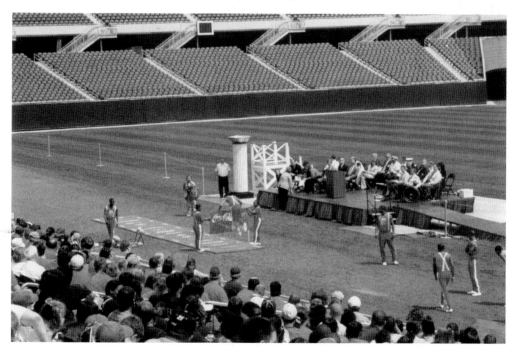

Mission:

Special Olympics provides year-round sports training and competition in a variety of Olympic-type sports for children (ages 8 years and older) and adults with intellectual disabilities,* giving them continuing opportunities to develop physical fitness, demonstrate courage, experience joy and participate in a sharing of gifts, skills and friendship with their families, other athletes and the community.

*Such as those who have functional limitations, both in general learning and in adaptive skills including recreation, independent living, self-direction or self-care.

Structure ▼

Illinois is divided into 17 areas (see back cover), each managed by an Area Director who supervises year-round training, competition and area fundraising for his/her area. Special Olympics Illinois, headquartered in Normal, has a staff that oversees all aspects of the statewide program and carries out the vision of the board of directors. Programs exist in all 50 of the United States and in more than 150 countries through Special Olympics, Inc., based in Washington, D.C.

Funding ▼

Special Olympics Illinois is a nonprofit, tax-exempt organization that raises funds through individual and corporate donations, foundation grants, service clubs and special events. Special Olympics Illinois is not funded by government agencies or the Kennedy Foundation and is not a United Way agency.

Training and Competition ▼

In all Special Olympics Illinois programs, athletes must train for a minimum of eight weeks before competing. Competition, conducted according to generally accepted rules for the particular sport, begins at the area or district level, and gold medal winners proceed to the next level of competition. World Games are held every two years, with summer and winter games alternating. Each year in Illinois there are more than 175 sanctioned competitions in 19 different sports, including seven state tournaments.

A
**Spectrum
of Choices**

INSPIRE
GREATNESS

Special Olympics
Illinois

Sample pages from a Special Olympics brochure titled *A Spectrum of Choices* detail the mission and organization of the Illinois Special Olympics.

A New Den

for the Bears

You never want it to end, especially when the fun is still there.

—Walter Payton, after his final game in 1988 with the Chicago Bears

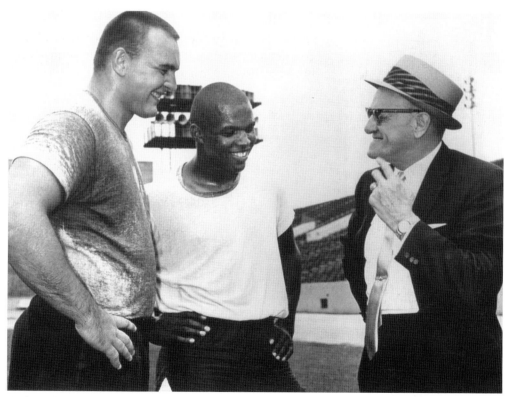

Dick Butkus and Gale Sayers enjoy a lighthearted moment with George "Papa Bear" Halas in their new home at Soldier Field.

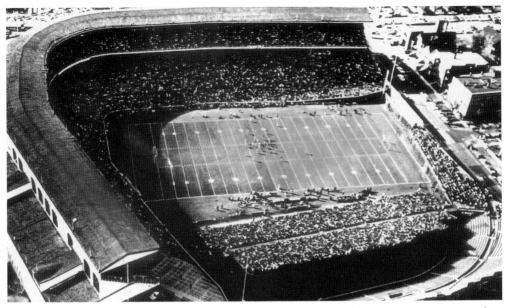

For almost five decades, the Chicago Bears called Wrigley Field their home. To accommodate football games in a baseball park, the gridiron was laid out over the infield and into left field, and bleachers were placed in right field. In 1970, Wrigley Field was deemed too small to accommodate the increasingly growing fan base, and the NFL demanded a venue that could hold 50,000. In their final game at the north side environs, the Bears defeated the Green Bay Packers 35-17 on December 13, 1970. The Bears left Wrigley Field with an all-time record of 221-89-22. These 332 games were the most ever played by one team in a home stadium in NFL history.

Northwestern University's Dyche Stadium (now Ryan Field) in Evanston was the short-lived home to the Bears for the first game of the 1970 season until local residents complained to town officials about fan behavior. Public intoxication coupled with trash on residents' lawns caused the Bears' eviction from Dyche Stadium, forcing the team back to Wrigley Field until their move to Soldier Field in the following year.

A NEW DEN FOR THE BEARS

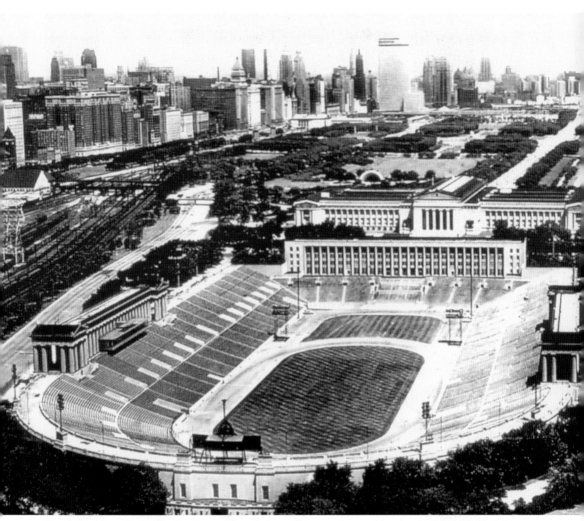

On September 19, 1971, the Bears played their first new home game at Soldier Field, defeating the Pittsburgh Steelers 17-15 before a crowd of just under 56,000.

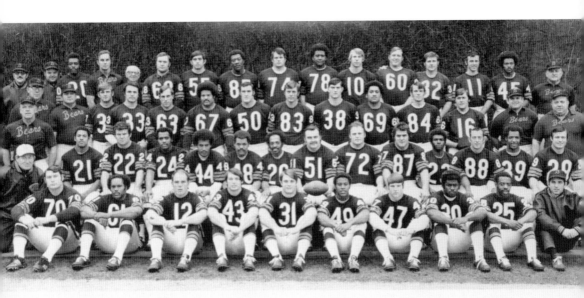

CHICAGO BEARS, 1970

TOP ROW: Bernie Lareau, Ron Zera, Joe Taylor, Jim Dooley, Frank Halas, Howard Mudd Doug Buffone, Willie Holman, Wayne Mass, Harry Gunner, Bobby Douglass, Lee Roy Caffey, Ralph Kurek, Jack Concannon, Dick Gordon, Perry Moss.
THIRD ROW: Bob Shaw, Jim Ringo, Rich Coady, Mike Hull, John Neidert, George Seals, Bob Hyland, Mac Percival, Ray Ogden, Ted Wheeler, Jim Seymour, Kent Nix, Don Shinnick, Abe Gibron.
SECOND ROW: Ed Cody, Cecil Turner, Ross Montgomery, Don Shy, Garry Lyle, Ron Smith, Bennie McRae, Dick Butkus, Jim Cadile, Ed O'Bradovich, Dick Daniels, Bobby Joe Green, Phil Clark, Ron Bull.
FRONT ROW: Ed Rozy, Jeff Curchin, Glen Holloway, Bob Cutburth, George Farmer, Ross Brupbacher, Terrell Ray, "Butch" Davis, Jimmy Gunn, Linzy Cole, Fred Caito (Absent when picture was taken: Craig Baynham, Dave Hale, Jim Hester, Randy Jackson, Gale Sayers, Bill Staley, Bob Wallace)

This group photograph is of the 1970 Chicago Bears players and coaches. In their 51st season with the NFL, the team posted a 6-8 record.

A NEW DEN FOR THE BEARS

1971 Training Camp Roster

(Ages as of Sept. 19, 1971; d-duplicate numbers)

NO.	NAME	POS.	HT.	WT.	AGE	PRO YEAR	SCHOOL
9	Coble, Bob	P	6'0"	190	23	1	Kansas State
10	Douglass, Bobby	QB	6'4"	228	24	3	Kansas
11	Concannon, Jack	QB	6'3"	200	28	8	Boston College
12	Cutburth, Bob	QB-P	6'2"	218	23	1	Oklahoma State
14	Lee, Buddy	QB	6'4"	205	23	1	Louisiana State
15	Maciejowski, Ron	QB	6'2"	195	22	1	Ohio State
16	Nix, Kent	QB	6'2"	198	27	5	Texas Christian
d-17	Hardy, Cliff	CB	6'0"	188	24	1	Michigan State
d-17	Hurley, Steve	PK	5'10"	180	23	1	Arizona
18	Moore, Jerry	S	6'3"	208	22	1	Arkansas
19	McClain, Lester	WR	6'3"	190	22	1	Tennessee
20	Taylor, Joe	CB	6'1"	200	30	5	North Carolina A&T
21	Turner, Cecil	WR	5'10"	176	27	4	Cal. Poly
22	Montgomery, Ross	RB	6'3"	220	24	3	Texas Christian
23	Daniels, Dick	S	5'9"	180	25	6	Pacific (Oregon)
24	Shy, Don	RB	6'1"	210	25	5	San Diego State
d-25	Cole, Linzy	WR	5'11"	170	23	2	Texas Christian
d-25	Williams, Harold	S	6'0"	192	22	1	Tulsa
26	McRae, Bennie	CB	6'0"	180	31	10	Michigan
27	Clark, Phil	S	6'3"	205	26	5	Northwestern
29	Bull, Ron	RB	6'0"	205	31	10	Baylor
30	Gunn, Jimmy	LB	6'1"	220	22	2	Southern California
31	Brupbacher, Ross	LB	6'3"	215	23	2	Texas A&M
32	Ford, Charlie	CB	6'3"	185	22	1	Houston
33	Hull, Mike	RB	6'3"	220	26	4	Southern California
34	Ferris, Dennis	RB	6'1"	200	23	1	Pittsburgh
35	Harrison, Jim	RB	6'4"	235	23	1	Missouri
36	Lewis, Willie	RB	6'2"	225	26	1	Arizona
d-37	Falk, Peter	PK-P	6'1"	190	22	1	Concordia (Minn.)
d-37	Rakow, Bill	S	5'10"	180	24	1	Adams State (Utah)
d-38	Ogden, Ray	TE	6'5"	225	29	7	Alabama
d-38	Ray, Terrell	CB	6'0"	170	25	1	Southern California
d-39	Kleemeier, Jon	PK	5'10"	180	25	1	None
d-39	Lumpkin, John	WR	6'3"	180	22	1	Fisk
40	Sayers, Gale	RB	6'0"	200	28	7	Kansas
43	Farmer, George	WR	6'4"	214	23	2	UCLA
44	Lyle, Garry	S	6'2"	198	25	4	George Washington
45	Gordon, Dick	WR	5'11"	190	27	7	Michigan State
46	Baynham, Craig	RB	6'1"	205	27	5	Georgia Tech
d-47	Davis, John "Butch"	CB	5'11"	188	23	2	Missouri

Pictured on this page is a copy of the 1971 training roster.

1971 Training Camp Roster *(Continued)*

NO.	NAME	POS.	HT.	WT.	AGE	PRO YEAR	SCHOOL
d-47	Rose, Ted	TE	6'6"	240	24	1	Northern Michigan
48	Smith, Ron	CB	6'1"	195	28	7	Wisconsin
49	Moore, Joe	RB	6'1"	205	22	1	Missouri
50	Hyland, Bob	C	6'5"	250	26	5	Boston College
51	Butkus, Dick	LB	6'3"	245	28	7	Illinois
52	Coady, Rich	C-TE	6'3"	245	26	2	Memphis State
53	Rowden, Larry	LB	6'2"	220	22	1	Houston
54	Garganes, Ray	LB	6'1"	215	23	1	Millersville (Pa.)
55	Buffone, Doug	LB	6'3"	230	27	6	Louisville
57	Scrivner, Gary	C	6'4"	240	21	1	Willamete (Ore.)
58	Packard, Scott	G	6'4"	245	23	1	Southern Illinois
59	Salmons, Dave	G	6'4"	245	22	1	Cal. State
60	Caffey, Lee Roy	LB	6'3"	240	30	9	Texas A&M
61	Holloway, Glen	G	6'3"	250	23	2	North Texas State
62	Barnett, Billy Bob	DT	6'5"	245	24	1	Texas A&M
d-63	Neidert, John	LB	6'2"	230	25	4	Louisville
d-63	Willis, Mark	G	6'3"	245	23	1	Iowa Wesleyan
64	Brown, Steve	G	6'3"	242	22	1	Indiana
65	Jackson, Randy	T	6'5"	250	27	5	Florida
67	Seals, George	DT	6'3"	260	28	8	Missouri
68	Mudd, Howard	G	6'2"	250	29	8	Hillsdale (Mich.)
69	Wheeler, Ted	G	6'3"	245	26	4	West Texas State
70	Curchin, Jeff	T	6'6"	255	23	2	Florida State
71	McGee, Tony	DE	6'4"	250	22	1	Bishop (Texas)
72	Cadile, Jim	G	6'3"	250	31	10	San Jose State
74	Mass, Wayne	T	6'4"	255	25	4	Clemson
75	Hale, Dave	DT	6'8"	255	24	3	Ottawa (Kan.)
76	Staley, Bill	DT	6'3"	250	25	4	Utah State
d-78	Gunner, Harry	DE	6'6"	250	26	4	Oregon State
d-78	Newton, Bob	T	6'4"	250	22	1	Nebraska
d-79	Bailey, Sid	DE	6'4"	245	22	1	Texas at Arlington
d-79	Weiss, Karl	T	6'5"	255	22	1	Vanderbilt
81	Schumacher, Gregg	DE	6'2"	240	29	4	Illinois
82	Thomas, Earl	TE	6'3"	224	22	1	Houston
83	Percival, Mac	PK	6'4"	220	31	5	Texas Tech
84	Seymour, Jim	WR	6'4"	210	24	4	Notre Dame
85	Holman, Willie	DE	6'4"	250	26	4	S. Carolina State
86	Hester, Jim	TE	6'4"	240	26	5	North Dakota
87	O'Bradovich, Ed	DE	6'4"	255	31	10	Illinois
d-88	Green, Bobby Joe	P	5'11"	175	35	12	Florida
d-88	Kerr, Gary	WR	6'4"	210	24	1	Cal. Poly
89	Wallace, Bob	TE	6'3"	220	25	4	Texas at El Paso

Bears' 1971 NFL Schedule

(All times are local; *—interconference game)

DATE	OPPONENTS	SITE	KICKOFF
Sept. 19	*PITTSBURGH	SOLDIER FIELD	1:05
Sept. 26	Vikings	Minnesota	1:00
Oct. 3	Rams	Los Angeles	1:00
Oct. 10	NEW ORLEANS	SOLDIER FIELD	1:05
Oct. 17	Forty Niners	San Francisco	1:00
Oct. 24	Lions	Detroit	1:00
Oct. 31	DALLAS	SOLDIER FIELD	1:05
Nov. 7	GREEN BAY	SOLDIER FIELD	1:05
Nov. 14	WASHINGTON	SOLDIER FIELD	1:05
Nov. 21	DETROIT	SOLDIER FIELD	1:05
Nov. 29 (Mon.)	*Dolphins	Miami	9:00
Dec. 5	*Broncos	Denver	2:00
Dec. 12	Packers	Green Bay	1:00
Dec. 19	MINNESOTA	SOLDIER FIELD	1:05

Preseason

SEPTEMBER 12—*DENVER BRONCOS AT SOLDIER FIELD 1:05

AWAY

(A—afternoon game)

Aug. 7 Packers at Milwaukee.....8:00
Aug. 14 *Colts at Baltimore......8:00
Aug. 21 Vikings at Minnesota......8:00

Aug. 28 (A) *Browns at Notre Dame 1:30
Sept. 4 *Oilers at Houston.........8:00

CLUB DIRECTORY

George S. Halas, *Chairman of the Board*
George Halas, Jr.,
 President and General Manager
Ed McCaskey..*Vice President-Treasurer*
Ralph D. Brizzolara...........*Secretary*
Bobby Walston.*Assistant to the President and Director of Player Personnel*
Jim Dooley*Head Coach*
Bill Austin*Coach*
Abe Gibron*Coach*
Perry Moss*Coach*
Jim Ringo*Coach*
Bob Shaw*Coach*
Don Shinnick*Coach*
Luke Johnsos...*Dir. Technical Research*

Ed Cody........*Dir. Professional Talent*
Rudolf P. Custer.....*Business Manager*
Frank Halas*Traveling Secretary*
Dan T. Desmond....*Information Director*
Dr. L. L. Braun.......*Team Physician*
Dr. Theodore Fox.......*Team Physician*
Ed Rozy.........*Dir. Training Services*
Bernie Lareau*Trainer*
Paul Patterson*Player Relations*
Jack Brickhouse*Radio Play-by-Play*
Irv Kupcinet*Radio Commentary*
Mack Haraburda*Auditor*
Cecil Kokenos*Coaching Staff Aide*
Lew Merrell*Game Programs*
Howard Mendelsohn.....*Chi. Adv. Rep.*

A copy of the Bears' 1971 NFL schedule lists the eight (including preseason) home games at Soldier Field.

A NEW DEN FOR THE BEARS

An essay titled " '71 Goal . . . Continue on the Rise" details hopes and plans for the upcoming season.

'71 Goal . . . Continue on the Rise

All the Bears need do in 1971 is resume the momentum that was theirs at the end of '70. In short, stay on the upbeat and the past can be forgotten.

For the first time since they came to Chicago in 1921, the Bears will have a new home site for NFL games this year. They'll play at 54,000-capacity Soldier Field where an extensive program of modernizing improvements includes an Astroturf gridiron.

Distasteful, disastrous 1969 (an unprecedented one win only in fourteen starts) was partially removed in 1970 as a memory that gnaws at the Bears' intense pride in tradition. They finished 6-8, but there still was the feeling that it could have been or should have been better—over .500 at least, because several of the losses came after the Bears were in control through a full half and into a third quarter only to let down.

But 1970's finishing kick was significant. Three of the last six games were won decisively. The three that were lost were by a total of only FIVE points. And most important of all, that happened at a stage of the NFL schedule where the Bears were out of contention with only pride and morale as incentive.

The Bears didn't merely play out the string—they were "up" for six consecutive weekends and now the hope is the improvement will carry over into this season.

The late development probably is best explained by the offseason trades and a productive draft that brought about an unusually high revision of manpower. Consequently, time was needed for all of the new parts to fit in with the reliable holdovers.

At the cost of the first two draft choices for 1970 and two starting linemen (Rufus Mayes and Dick Evey), the Bears acquired nine quality players with solid big league credentials. Eight of them made it, six as starters and two as valuable "spot" performers.

Starting of necessity on the third round of the college draft, the Bears had excellent results anyway—seven rookies with more than enough talent to be trusted in situations that enabled them to get in considerable playing time.

This year, the Bears got a full count, plus, in the draft—eighteen choices of whom five came on the first three rounds. Three of those five were among the first thirty-six collegians picked—No. 1 Joe Moore and No. 2-a James Harrison, both running backs from Missouri; No. 2-b Charles Ford, Houston defensive back who was tenth on the second round.

Good distribution, offense and defense, is expected to add to the depth and take care of any future manpower emergencies.

Gale Sayers, who got into only two games in 1970 because of injury to his left knee requiring surgery about ten days after it happened and off-season operative procedures as well, fully expects to come back as elusively effective as ever.

One objective is to bring the ground game closer to parity with the air attack. Last year, offensive yardage broke down into 33.5 percent on rushing, 66.5 percent on passing and the league ratio is roughly 43 to 57.

The air attack was forceful as Dick Gordon led all pro receivers, NFC and AFC, with 71 catches for 1,026 yards and 13 touchdowns. He was all-NFL selection as a wide receiver, joining team-mate Dick Butkus, picked as middle linebacker for the fifth time in six seasons.

Butkus, by the way, also underwent offseason knee surgery for reconstruction of loose ligaments, a condition that had existed for fourteen years.

Besides Gordon, impressive receivers included a pair of first year men, third draft choice George Farmer who caught 31 for 496 yards and Jim Seymour, one of two Rams coming to the Bears in the Evey trade, who picked off only six passes but four were for touchdowns. Seymour made only seven game appearances because a pulled muscle delayed his start with the Bears.

Quarterbacks Jack Concannon and Bobby Douglass each had a four-touchdown afternoon, the former against Green Bay and the latter against Buffalo.

Another bright development in 1970 was the kickoff return unit. Cecil Turner led individual kickoff runners-back and scored four touchdowns (tieing the NFL record) in the course of building a 26.3 yard average. As a team, the Bears missed the leadership by one-hundredth of a percentage point, 26.285 average yards to 26.295 for the Los Angeles Rams.

Defensively, the Bears tied for first in fewest average yards per rushing play allowed (3.2); fourth low in total yards rushing allowed (1,471); and fifth in first downs rushing (83). Those compare with the NFC averages of, respectively, 3.8; 1,679; and 88.

Among individual accomplishments besides those already mentioned, Doug Buffone's four pass interceptions were the most by any Bears' outside linebacker in one season, and Ron Smith set two new team records with 33 punt returns and 28 kickoff runbacks.

Documenting the upsurge over the last six-game stretch are these statistics:

DEFENSE—Opponents average rushing yardage per game cut to 255.3 yards for last six as against 316.9 for first eight; passing yardage to 146.1 from 214.9; percentage completed passes to 54.8 from 62.2; thirteen pass interceptions from four.

OFFENSE—Overall yardage average per game up to 275.8 from 201.3 for first eight; rushing, 83.7 from 73.8; passing, 192.1 from 127.5.

Apart from the one-point losses to Baltimore and Green Bay and the three-point defeat by Minnesota, there is evidence the Bears were in contention in four of the other five games they dropped. They led Detroit at the half in both meetings; set the pace for San Francisco at the half; and tied San Diego at the end of the first two periods. Only in the first Minnesota game were they completely outclassed from opening kickoff to final gun.

As Soldier Field proved a less-than-ideal home for the Bears during the 1970s, longtime leader George Halas considered moving the team to Arlington Heights, a suburb north of the city.

A NEW DEN FOR THE BEARS

One notable vignette captured by Scott Simon in his 2000 book, *Home and Away: Memoir of a Fan*, captured Mayor Richard J. Daley's comments to Halas on a possible move out of the city: "I think that's fine, George. You're a businessman. Do what you have to do. By the way, our lawyers say you can't take the name Chicago with you out there. We'd have to take you to court. That could take years. I wonder how many people will come out to see The Arlington Heights Bears? I wonder how excited the network people will be about broadcasting The Arlington Heights Bears? You're a fine businessman, George. You make the call." Halas, of course, chose to stay.

Between 1979 and 1982, major renovation projects began to improve and preserve the historic venue by adding new lighting, locker rooms, and more comfortable seats, in addition to deluxe skybox seating, a computerized scoreboard, and updated concession stands. This first renovation took place under Mayor Jane Byrne, and the stadium was rededicated in 1983.

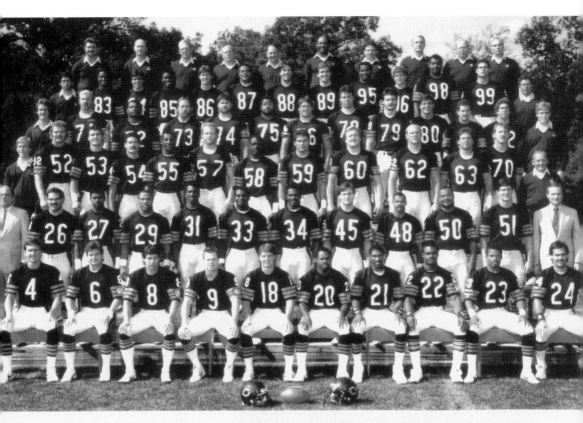

1985 CHICAGO BEARS – SUPERBOWL CHAMPIONS

FIRST ROW: (from left):
Steve Fuller (4), Kevin Butler (6), Maury Buford (8), Jim McMahon (9), Mike Tomczak (18), Thomas Sanders (20), Leslie Frazier (21), Dave Duerson (22), Shaun Gayle (23), Jeff Fisher (24)

SECOND ROW:
Jerry Vainisi, Matt Suhey (26), Mike Richardson (27), Dennis Gentry (29), Ken Taylor (31), Calvin Thomas (33), Walter Payton (34), Gary Fencik (45), Reggie Phillips (48), Mike Singletary (50), Jim Morrissey (51), Michael McCaskey

THIRD ROW:
Pete McGrane, Cliff Thrift (52), Dan Rains (53), Brian Cabral (54), Otis Wilson (55), Tom Thayer (57), Wilber Marshall (58), Ron Rivera (59), Tom Andrews (60), Mark Bortz (62), Jay Hilgenberg (63), Henry Waechter (70), Ray Earley

FOURTH ROW:
Brian McCaskey, Andy Frederick (71), William Perry (72), Mike Hartenstine (73), Jim Covert (74), Stefan Humphries (75), Steve McMichael (76), Keith Van Horne (78), Kurt Becker (79), Tim Wrightman (80), James Maness (81), Ken Margerum (82), Gary Haeger

FIFTH ROW:
Fred Calto, Willie Gault (83), Brian Baschnagel (84), Dennis McKinnon (85), Brad Anderson (86), Emery Moorehead (87), Pat Dunsmore (88), Mitch Krenk (89), Richard Dent (95), Keith Ortego (96), Tyrone Keys (98), Dan Hampton (99), Clyde Emerich

SIXTH ROW:
Mike Ditka, Ted Plumb, Ed Hughes, Dale Haupt, Jim LaRue, Johnny Roland, Steve Kazor, Dick Stanfel, Buddy Ryan, Jim Dooley

The 1985 team included a colorful and talented cast of players that outscored Detroit, Dallas, and Atlanta by a combined score of 104-3 in November, edged out the Los Angeles Rams and New York Giants in the playoffs, and defeated the New England Patriots 46-10 in the 1986 Super Bowl. The team, with future Hall of Fame immortals Walter Payton, Dan Hampton, and Mike Singletary, even recorded the unforgettable *Super Bowl Shuffle*. Remembering the 1985 team in a 2007 Associated Press news article by sportswriter Andrew Seligman, Mike Ditka said, "It was more than a team. It was a team of characters that had character that played for a crazy man, who let him be crazy and had fun doing it and don't apologize for it ever. I wouldn't want to be one of these suits walking around on the sideline today. I have no desire to be that. I was what I was and they were what they were and, damn, it was fun."

A NEW DEN FOR THE BEARS

Here are two profiles of Coach Ditka; one on the field expressing his obstinacy, and the other of the coach holding the Vince Lombardi trophy from Superbowl XX.

CHICAGO'S SOLDIER FIELD

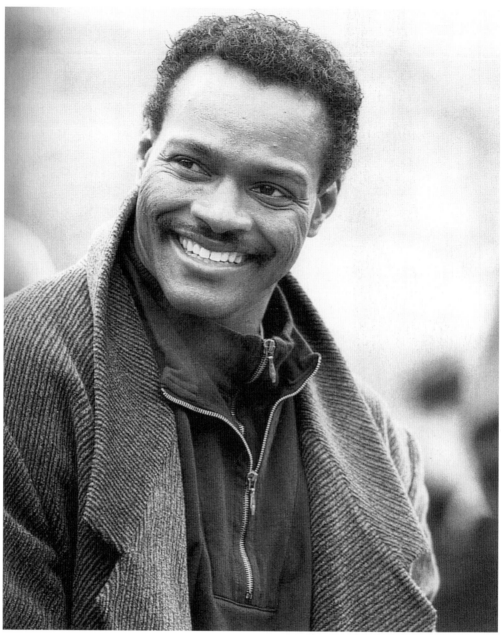

On November 6, 1999, Bears legend Walter Payton—also known as "Sweetness"—was honored with a public memorial service at Soldier Field after succumbing to cancer five days earlier. As a running back that the Bears had drafted in the fourth overall selection in 1975, Payton was the highest-ranked Bears player and the second-highest-ranked running back behind Jim Brown. In his comments about Payton, the NFL hall of famer and all-time leading rusher, former coach Mike Ditka said, "It's a sad time, but yet, God called him home. I believe Mr. Halas has him up in heaven right now, and he's finally got the last piece of the puzzle. He's got the greatest Bear of all time."

Today Soldier Field passersby can see Honorary Walter Payton Place, which runs along Lake Shore Drive.

THE BEARS PROGRAM

Friday/August 21, 1998 Soldier Field, Chicago

PRESEASON GAME #1

BEARS VS BILLS

The Chicago Bears host the Buffalo Bills today in the first of two exhibition games preceeding the 1998 NFL Season. Television coverage will be provided by WBBM Chicago Channel 2 with radio broadcast on WMAQ 670 AM.

- **GATES OPEN** at 5:30pm.
- **GAME TIME** is 7:00pm.
- **NATIONAL ANTHEM** performance this evening is provided by Octane, an acapella group from DeKalb, Illinois.
- **HALFTIME ENTERTAINMENT** features the All-Star Drill Team and Coca-Cola Kickoff promotional contest.
- **FAN ASSISTANCE BOOTHS:** Gates 0, 15, 16. 27 and 28.
- **PROMO BOOTHS:** Fan Club and MBNA Bank NFL Credit Card.
- **GAME DAY FEATURES** include the Cellular One Lucky Seat Giveaway during halftime and Nicolet Water Girl & Boy Tee grab after the opening kickoff.

Building a Championship Service Season

"The Program" was a stadium staff service brief designed to introduce Soldier Field personnel to updates in service operations and improvements in customer relations.

SO WHAT IS THE PROGRAM?

In a continuing effort to enhance guest safety and service, the Chicago Bears, working in conduction with the management of Soldier Field, Garcia Security and Safety Service Systems have initiated some new service operations for the 1998 season. We call it **THE PROGRAM** and model it after building a championship football team. **THE PROGRAM** will provide us with the tools to be more proactive in our approach to guest service operations.

COMBINED SERVICES APPROACH
At the heart of **THE PROGRAM** is a plan to coordinate the supervision of security and usher staff by developing a joint supervisory approach.

CENTRAL COMMAND SYSTEM
To manage our combined services approach, an operation network is being developed between three stadium locations.
- **GATE 4 OFFICE:** Administration
- **RAMP 15 SECURITY OFFICE:** Crowd and Occurrence Management
- **EAST SIDE BOX:** Command Center directing Operations

SERVICE BRIEF INFORMATION NETWORKING
What you are reading—the first of at least ten editions this season. The Service Brief is a game day bulletin, providing information about event planning and guest services. We are asking all stadium personnel to be part of our quality guest service effort and present the Service Brief as a tool to use when doing your job. The Service Brief is part of the Information Network, a custom-designed PC database that will help us organize and use game information more efficiently.

This 1998 bulletin offers a behind-the-scenes look at the responsibilities of the people who make game days run safely and smoothly.

AND WHY SHOULD I CARE?

Because we are asking you to. Because you should. Service is your business; all of our jobs here exist to provide for the safety and/or service of the guests of Soldier Field. Beyond that, we have a deeper responsibility to treat each other with the same respect and friendly attitude we hope to recieve. The Chicago Bears and the management of the organizations responsible for game day operations are taking extra care to make Soldier Field a more enjoyable place to work and play. Game day employees are the frontline representatives of Bears football and we need your help making the 1998 season a guest service success. When a guest asks directions, now you can direct them. If an emergency occurs, you will know where to get help. When you'd like to know a little more about what's going on, we offer the Service Brief. Designed to provide up to date information about game day events and user friendly reference guides (like the the stadium map on the back page), future editions will include additional reference guides to help you be more proactive and helpful to guests. Service is a committment to care about others, and doing the job in a friendly way is the fun part. Thank you for your efforts.

CHICAGO BEARS
Bill McGrane, Director Of Administration
George McCaskey, Ticket Manager
Caroline Guip, Skybox Manager
Bryan Pett, Stadium Assistant

SOLDIER FIELD JOINT VENTURE
Bob Glazebrook, General Manager
Jim Duggan, Director Of Operations

CHICAGO PARK DISTRICT
Elenor Lipinsky, Lakefront Operations
Bridget Reidy, Mayor's Office
Amy Degnan, Mayor's Office

ARAMARK FOOD SERVICE
Kevin Walsh, Manager
Jay Boyle, Regional Manager

M*A*S*E*
Logan Tanner, Manager
Jacob Willens, Manager

SAFETY SERVICE SYSTEMS
Paul Gerlach, Executive Director
Jim Hennessy, Operations Manager

GARCIA SECURITY
Hector Garcia, President
Roger Whalen, Manager

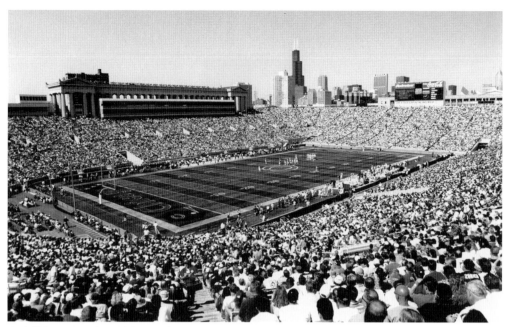

A full house packs Soldier Field when a full scenic view of the Sears Tower and surrounding skyline was still available to spectators.

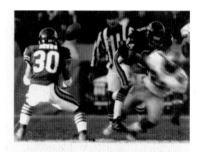

Comeback Culmination

SEC 17 ROW 29 SEAT 1
 257745

NFC PLAYOFF GAME

SOLDIER FIELD
DATE & KICKOFF TIME TO BE ANNOUNCED

This ticket stub is for the final game ever played at old Soldier Field in Chicago, between the Eagles and the Bears on January 19, 2002. This was a playoff game for the 2001 season in which Eagles quarterback Donovan McNabb returned to his hometown to face the Bears, who were hosting their first playoff game since 1991.

A NEW DEN FOR THE BEARS

The "New"

Soldier Field

Soldier Field is a civic structure, after all. It's a vestige of the City Beautiful tradition of grand axes and ornate facades that architect, urban planner, and Chicagoan Daniel Burnham so ingrained in the city at the turn of the last century. But nostalgia and Doric columns aside, the stadium perhaps more importantly rests in Chicago's civic core. On the shores of Lake Michigan just south of a healthy central business district, it sits across the street from the Museum Campus, a thriving waterfront cluster of sizable Beaux Arts and Art Deco buildings set among parks.

—Aric Chen, freelance architecture/design, and decorative arts writer

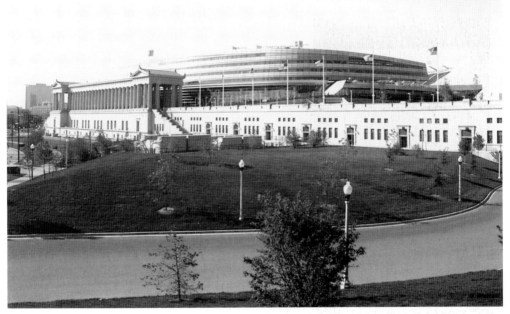

ABC's *Monday Night Football* crew descended on Chicago to cover the return of the Bears to the "new" Soldier Field on September 29, 2003, after a one-season hiatus in Memorial Stadium at the University of Illinois at Champaign-Urbana. Bears legends Dick Butkus and Mike Singletary were on hand to help christen the new facility. Unfortunately, the historic rival Green Bay Packers did not grant the Chicago Bears a welcome home victory as Brett Favre led the victory over the Bears by a final score of 38-23.

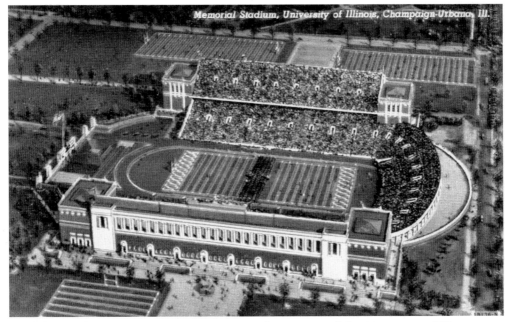

Memorial Stadium, located in Champaign on the campus of the University of Illinois, was dedicated as a memorial to the Illinois men and women of World War I and World War II. The stadium opened on November 3, 1923, with a construction cost of $1.7 million and with a seating capacity of just under 70,000. The Chicago Bears spent the 2002 season at Memorial Stadium while Soldier Field underwent its $365 million reconstruction.

THE "NEW" SOLDIER FIELD

SOLDIER FIELD FACTS

Ground Breaking Date January 19, 2002
Capacity: Approximately 61,500
Construction Schedule: 20 months
(Shortest construction time for modern day stadium on record)

Playing Surface: Natural grass

Materials Breakdown

150,000 cubic yards of excavation

2,800 steel piles

40,000 cubic yards of concrete

2,915 tons of rebar

310,000 square feet of precast

575,000 square feet of metal decking

8 escalators

1,600 doors

9 passenger elevators

3 service elevators

590,000 square feet of masonry

190,000 square feet of glass curtain wall

250 linear feet of custom stone countertops

Other Amenities

17 acres of green space and 1,400 new trees

280-foot granite Veteran's Memorial Water Wall to honor American veterans of all wars

Bronze Doughboy statue at Gate "O" symbolizing World War I soldiers

133 Suites and 8,600 Club Seats

Seats at the new Soldier Field are an average of 37 feet closer to the action

Two 23'x 82' video boards located in the north and south end zones

600 feet of ribbon panel LED signage, featuring game stats, advertising and other fun fan features

Hybrid sound system, consisting of three large clusters of speakers and 162 individual speaker boxes throughout the seating bowl with 165 amplifiers producing more than 100,000 watts of sound power

Nearly 1000 televisions scattered throughout the stadium

Three times as many concession stands as the old Soldier Field

Twice as many restrooms as the old Soldier Field

Wider seats with cup holders

Three-level Stadium Club

Year-round access to the Colonnade Level

Open-air Courtyard inside Gate "O"

A Soldier Field "facts" page from a tour program breaks down the numbers.

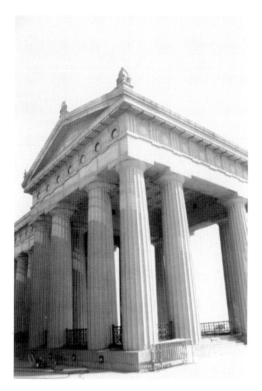

Considered by many to be the most distinctive feature of Soldier Field, the historic colonnades remained untouched as the new stadium was built within the existing structure. Now open and accessible to the public on nonevent days, the colonnades offer visitors magnificent elevated views of Lake Michigan and Burnham Harbor.

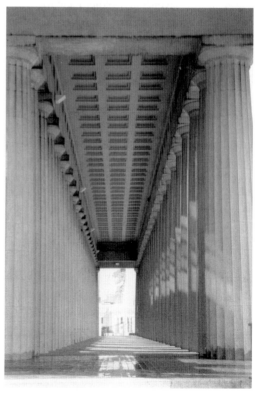

THE "NEW" SOLDIER FIELD

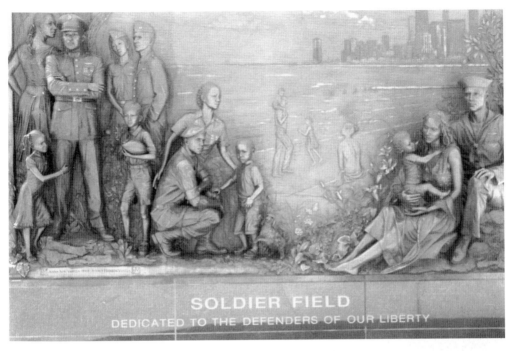

SOLDIER FIELD
DEDICATED TO THE DEFENDERS OF OUR LIBERTY

A 10-by-15-foot sculpture titled *Tribute to Freedom* was unveiled at Soldier Field in 2003. Chicago artists Anna Koh-Varilla and her husband, Jeffrey Varilla, created the sculpture, which depicts "men and women of diverse ethnic backgrounds . . . shown in the uniforms of the present." In a 2003 *Chicago Tribune* article written by the late columnist Steve Neal, the husband and wife team commented on the work: "Our concept [was] to emphasize the importance of family, loved ones, friends and home in the minds and hearts of our men and women in uniform," stated the Varillas. "What sustains our overseas troops in harm's way are their thoughts of returning to home and family. It is a known fact that many POWs have survived their ordeals because of their strong faith in eventually returning to their homes. This monument also reminds us that the primary function of our men and women in uniform is to defend our families, homes and way of life."

Transportation access to Soldier Field changed for the better as the new design incorporated 2,500 new underground parking spaces adjacent to the Field Museum of Natural History and the Shedd Aquarium. Pictured above is the ground-level lobby of the parking facility. The area is maintained in spotless condition and offers vending and cash station machines, public restrooms, and automated tellers for parking payment before returning to one's vehicle. Conveniently located just outside of the parking lot lobby is a year-round retail store (pictured below) offering Chicago Bears memorabilia to visitors of the museum campus.

THE "NEW" SOLDIER FIELD

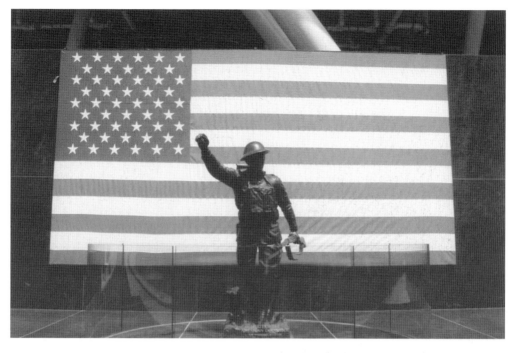

The *Spirit of the American Doughboy* World War I Memorial monument was sculpted by Ernest Moore Viquesney (1876–1946), a native of Spencer, Indiana, and the son and grandson of French sculptors. His seven-foot masterpiece was intended to be a tribute to all those who served and died in the "War to End All Wars." Viquesney, himself a veteran of the Spanish-American War, devoted all his spare time over a two-year period to perfecting his statue. He interviewed returning veterans, studied hundreds of photographs, and even had two local veterans model in their full combat regalia. Now stationed at Gate 0 in the south entrance of Soldier Field, the life-size bronze statue, badly damaged from vandalism years earlier, was discovered in storage at Garfield Park. Sculpture conservator Andzej Dajnowski restored the statue, using as his model a similar statue that stands in a military cemetery in Easton, Maryland. The statue was rededicated in 2003.

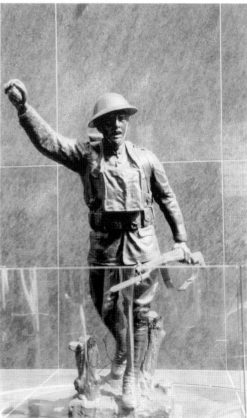

CHICAGO'S SOLDIER FIELD

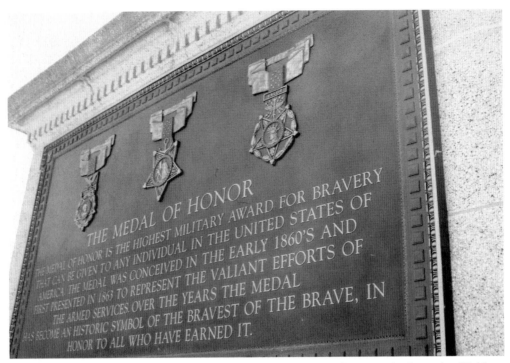

A bronze plaque adorns a south wall at the zenith of the stadium overlooking the Waldron Parking Deck. In the image above, one plaque details the history surrounding the Medal of Honor. Pictured below is a plaque detailing the names of American veterans who have earned the honor between the early years of the Civil War through the last year of World War I.

THE "NEW" SOLDIER FIELD

Along the wall surrounding the *Spirit of the American Doughboy* monument are benches containing notable quotations centering on the efforts of those who have served the United States. Military Medals of Honor (pictured above and below) donated by veterans from the various branches of the armed forces have been cast into the backrests.

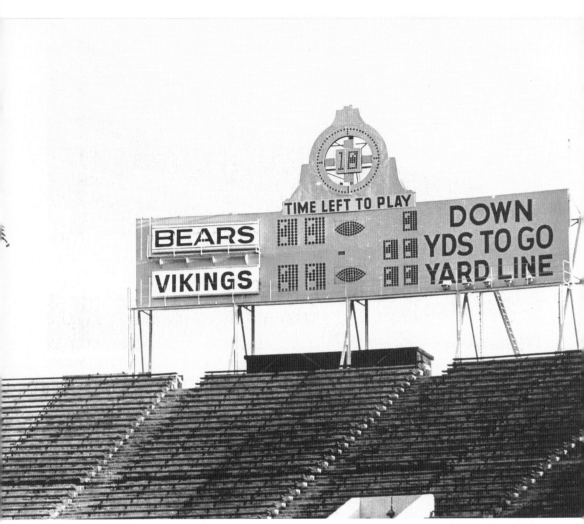

A photograph of the old scoreboard (pictured above) at Soldier Field taken prior to the 1970 game between the Chicago Bears and the Minnesota Vikings contrasted with the new electronic scoreboards that adorn the stadium today. Note the absence of any sponsorship on the vintage scoreboard compared with the corporate names that adorn today's state-of-the-art scoreboards (on the opposite page).

THE "NEW" SOLDIER FIELD

Between 1979 and 1982, major renovation projects began to improve and preserve the historic venue by adding new lighting, locker rooms, and more comfortable seats, in addition to deluxe skybox seating, a computerized scoreboard, and updated concession stands.

In 1988, the surface of the field was changed from artificial turf to natural grass. On a quiet day in May, long after the goalposts have been removed until the next season, a devoted groundskeeper meticulously picks stray weeds that mar the beauty of the playing surface.

Overlooking the stadium field and the Chicago skyline, the glass-enclosed sky suites at Soldier Field offer more luxury for socializing while watching the Bears play. The suites, which can hold 2–100 people, are available for meetings and smaller events at a cost of $1,500 to $3,500 per suite, with food and beverage service extra through the stadium's caterer.

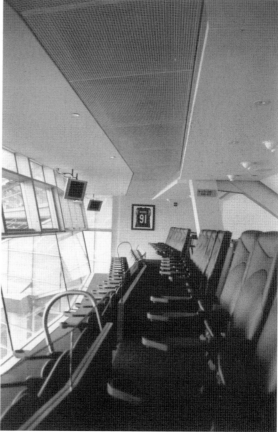

The visiting team's locker room, while not as extravagant as the Bears' locker room, offers ample space for suiting up and pregame meetings. The Bears' locker room includes plasma televisions while the visitors' locker room houses Zenith television sets.

THE "NEW" SOLDIER FIELD

Additional space just off the visitor locker room provides for visiting players' physical therapy and sports medicine needs, as well as amenities for a hot shower after the game. Note the height of the shower heads, built to accommodate the physical stature of today's players.

The celebration in the parking lot, also known as tailgating, offers a storied history dating back to 1869, when Rutgers and Princeton met for the first college football game. Traveling to the game by carriage, fans reportedly grilled food at the "tail" end of the horse prior to the event. The tailgate has grown in popularity and sophistication as spectators will spend equally as much time

THE "NEW" SOLDIER FIELD

enjoying a few pregame beers and burgers as they will watching the game. Portable electric grills, folding picnic tables, and the availability of a nearby "porta-potty" lend a greater appreciation to this autumn tradition across the nation. The photographs on these pages illustrate the typical tailgating scene that takes place on the Waldron parking deck before a Bears game.

CHICAGO'S SOLDIER FIELD

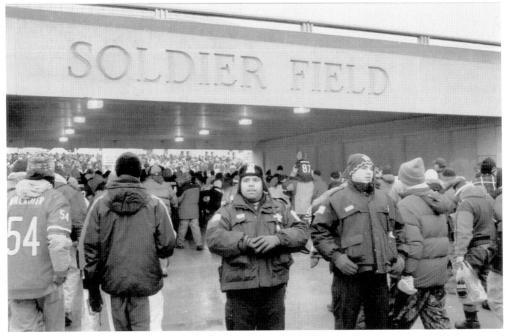

Chicago police officers Salgado and Villa of the Deering District exercise crowd control as spectators make their way to the stadium for the January 21, 2007, NFC championship game against the New Orleans Saints. The Bears won 39-14 before heading to Miami for the Superbowl.

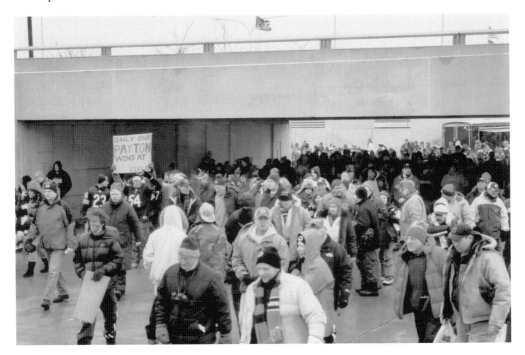

THE "NEW" SOLDIER FIELD

Anxious fans fight Chicago's winter doldrums with the hopes of going to the Superbowl. The fans above appear optimistic while the fan below remains guarded after catching the photographer enviously eyeing his headwear.

Members of the Chicago Police Department Mounted Unit maintain a presence outside of Soldier Field's Gate 0 during the January 21, 2007, NFC championship game.

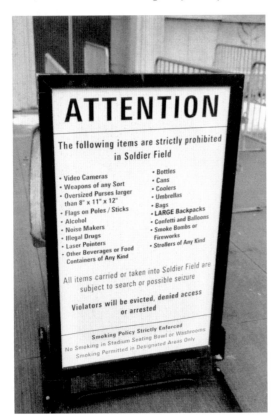

A sign listing prohibited materials stands like a sentinel outside of Soldier Field. Increased security and greater restrictions in large stadiums have been a necessity since September 11, 2001.

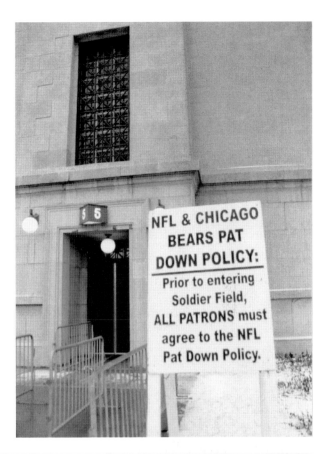

Patrons submit to the NFL and Chicago Bears "pat down" policy prior to entering the stadium gate. Monterrey Security has been providing services at Soldier Field for the past five years in addition to managing security for 150 annual events.

A ticket booth outside of Soldier Field offers 10 service windows. Individual game tickets for the Chicago Bears season typically go on sale in late July. Tickets are priced at $65 to $340 per game, with a limit of four tickets per customer per game.

THE "NEW" SOLDIER FIELD

STADIUM IN A PARK

It sits as the guardian of one of the most inspiring vistas in the land. If you can't be inspired gazing out toward Lake Michigan from Soldier Field, faced with the stark reality of one's smallness against the vastness of all else, I don't know what would inspire you.

—Kevin Stein, Poet Laureate of Illinois

A beautifully landscaped view of Soldier Field from the Children's Garden illustrates just one of the ways in which the 17-acre surrounding parkland has been upgraded.

Directional placards made to appear like faux street signs (pictured above) offer an added convenience for native Chicagoans and visitors learning to navigate their way around the museum campus. The Field Museum of Natural History (pictured below), opened in its current location in 1921, sits a few short steps away from Soldier Field. The Field Museum of Natural History was the site of the 1997 movie *The Relic*.

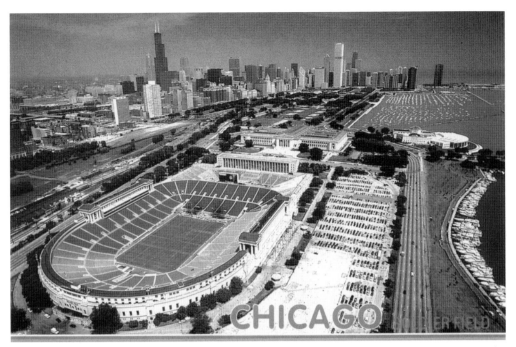

This postcard reflects a view of the stadium and museum campus prior to its reconstruction. The land surrounding the original Soldier Field included outside parking next to the stadium, limited parklands, and northbound lanes on Lake Shore Drive, which sat east of the stadium. What once existed as a stadium inside a parking lot has been transformed into a stadium inside a park.

On November 10, 1996, new northbound lanes on Lake Shore Drive opened next to the original southbound lanes at Soldier Field.

The area known as the South Loop and Near South Side has become the home to a newly gentrified residential district, in which new condominium development and loft conversions offer residents a dynamic area in which to live. The same area housed Chicago's worst slums in the 1940s.

STADIUM IN A PARK

In addition to daily bus service by the Chicago Transit Authority, trolleys offer visitors a unique way to see some of Chicago's most popular destinations. Many trolley rides (such as the one pictured below making a stop through the museum campus) in the city are free between Memorial Day and Labor Day.

The Children's Garden offers families and children an entertaining learning experience through its many earth, space, and science motifs.

STADIUM IN A PARK

The addition of the 17-acre parkland surrounding Soldier Field provides a welcoming outdoor area for individuals and families during the spring and summer months.

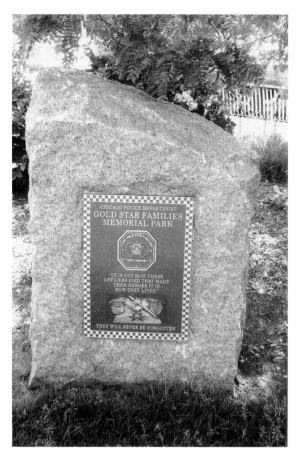

A candlelight vigil held on May 2, 2005, marked the groundbreaking ceremony for the Gold Star Families Memorial Park, a five-acre site that honors law enforcement personnel with a memorial wall listing the names of the 520 police officers killed in the line of duty since 1854. The park serves not only as a destination for people wishing to visit and view the memorial, but will also be inviting to visitors to the surrounding museum campus.

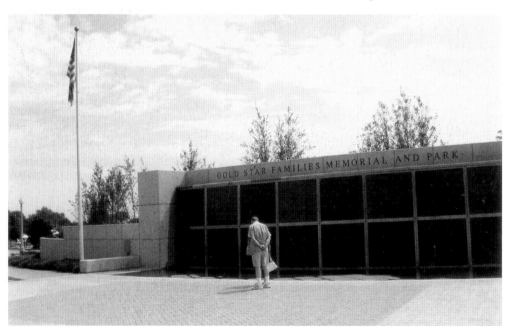

STADIUM IN A PARK

Chicago police department officer Michael Ceriale (pictured below), age 26, died on August 21, 1998, after being shot six days earlier in the line of duty. Ceriale, who had been working undercover narcotics surveillance, was the 414th Chicago police officer to die in the line of duty. The memorial brick located in front of the Gold Star Families Memorial Wall, directly across from Soldier Field, pays tribute to his sacrifice and the many other men and women who have given service to the city of Chicago.

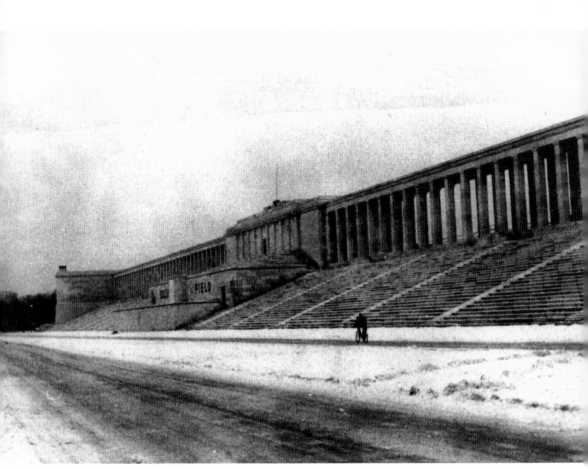

In the image above, dating back several decades, a lonely cyclist bikes through Soldier Field on a gray, snowy day.

STADIUM IN A PARK

Pictured here are two images illustrating the "new and improved" view cyclists, joggers, walkers, and other passersby now have on the bike path next to Burnham Harbor as a result of Daniel Burnham's original vision in his plan from nearly a century ago.

The ancient gargoyle was said to be a symbol of the juxtaposition or balance of ugliness against the beauty inside the building it protected. Perhaps in relating this interpretation to the surrounding area, one can conclude that this symbol will help balance the occasional ugliness prevalent in the city with the pure, unadulterated beauty provided by an afternoon inside Soldier Field.

BIBLIOGRAPHY AND SUGGESTED READING

Cavanaugh, Jack. *Tunney: Boxing's Brainiest Champ and His Upset of the Great Jack Dempsey*. New York: Random House, 2006.

Davis, Jeff. *Papa Bear: The Life and Legacy of George Halas*. New York: McGraw-Hill, 2005.

Kahn, Roger. *A Flame of Pure Fire: Jack Dempsey and the Roaring '20s*. New York: Harcourt Brace and Company, 1999.

Kamin, Blair. *Why Architecture Matters: Lessons from Chicago*. Chicago: University of Chicago Press, 2003.

Lott, Lee. *The Legend of the Lucky Lee Lott Hell Drivers*. Osceola, Wisconsin: Motorbooks International, 1994.

MacCambridge, Michael. *America's Game: The Epic Story of How Pro Football Captured a Nation*. New York: Random House, 2004.

Mead, Gary. *The Doughboys: America and the First World War*. New York: Overlook Press, 2000.

Simon, Scott. *Home and Away: Memoir of a Fan*. New York: Hyperion, 2000.

Smith, Carl. *The Plan of Chicago: Daniel Burnham and the Remaking of the American City*. Chicago: University of Chicago Press, 2006.

Taylor, Roy. *Chicago Bears History*. Charleston, South Carolina: Arcadia Publishing, 2004.

Across America, People are Discovering Something Wonderful. Their Heritage.

Arcadia Publishing is the leading local history publisher in the United States. With more than 3,000 titles in print and hundreds of new titles released every year, Arcadia has extensive specialized experience chronicling the history of communities and celebrating America's hidden stories, bringing to life the people, places, and events from the past. To discover the history of other communities across the nation, please visit:

www.arcadiapublishing.com

Customized search tools allow you to find regional history books about the town where you grew up, the cities where your friends and family live, the town where your parents met, or even that retirement spot you've been dreaming about.